The
Playing
Is The Thing

Learning the
Art of
Acting
Through Games
and Exercises

Anita Jesse

Wolf Creek Press

859 Hollywood Way, Suite 251
Burbank, CA 91505-2814

The Playing Is The Thing

Publisher's Cataloging in Publication

(Prepared by Quality Books Inc.)

Jesse, Anita
 The playing is the thing : learning the art of acting through games and exercises / Anita Jesse.
 p. cm.
 Includes bibliographical references and index.
 Preassigned LCCN: 96-61374
 ISBN: 0-9639655-1-4

 1. Acting. I. Title
PN2061.J47 1996 792'.028

 QBI96-40445

Published by **Wolf Creek Press**
 859 Hollywood Way, Suite 251
 Burbank, CA 91505-2814
 Phone: (818) 767-4616
 Fax: (818) 767-2679
 E-mail: WolfCrkPrs@aol.com

Acknowledgments

My husband, Jim Ingersoll, who patiently listened to the readings of all those first, second and third drafts. As a fellow teacher, he tested the games in his classes and provided invaluable data regarding the effectiveness of the games as presented here. I would never have completed the book without his generous support and his cogent comments.

My editor, Carol Woodliff. I don't even want to think about having done this book without her help. Carol's contributions are too numerous to mention. For example, she not only suggested the "Cross-Reference Chart" but executed it as well. A skilled and creative writer, she gave generously of her talents to this project. Her patience and perseverance are a source of amazement to me. Everyone who writes a book needs a Carol Woodliff. I am so grateful I had mine.

My students Candy Belzer, Deborah Harmon, Jennifer Hengstenberg, Michael Horton, Thom Hunt, Debbie McGee, John Pearson, Kenn Scott, Kelly Shipe, Chris Slagle, and Tommy Woelfel. I finally gave up and listed their names alphabetically, because I couldn't begin to organize them based on the significance of their contributions or even list all the ways in which they made a difference. Each member of this multitalented group left a major imprint on the final version of the book. I am lucky to have enjoyed the benefit of their amazing skills, keen observations, enthusiastic participation, and healing good humor.

Professor Maureen McIntyre for nagging incessantly, "When am I going to get my copy of the exercise and game book?" Her

steadfast support and indomitable enthusiasm for the project kept me going on the days when I was certain I would never finish.

My friends Jim Fox, Tim Morell, and Jack Rowe for all their encouragement, support and expert advice.

Finally, all my students throughout the years who have patiently taught me how to teach acting. It was their glorious commitment that revealed the true potential of the games and exercises. My wonderful actors, who came week after week forging new insights in the heat of risk, refined the meaning of this work through their insightful comments. Without my actors—without their inspiring talent, uncommon generosity, and radiant spirit—there would be no book. I thank them all from the bottom of my heart.

Preface

God bless actors. They make us laugh and cry—they make us cheer and boo. They terrify us and inspire us. But most of all they tell us who we are. The English essayist, William Hazlitt, wrote in 1817:

> They are ... train-bearers in the pageant of life, and hold a glass up to humanity, frailer than itself. We see ourselves at second-hand in them: they show us all that we are, all that we wish to be, and all that we dread to be What brings the resemblance nearer is, that, as *they* imitate us, we, in our turn, imitate them There is no class of society whom so many persons regard with affection as actors.

I work with actors on a daily basis and have the privilege of seeing them in their most vulnerable state. I watch them confront the terror of self-discovery and wrestle with the refinement of their craft. My heart breaks to see them suffer as they struggle with the questions, self-doubts, fears and disappointments. Then if they are persistent, I get to celebrate with them when they break through the invisible barriers and find themselves in the work.

Actors are spirit-warriors. They confront our demons for us. They scale the Mount Everest's of the soul in our stead. They rent out their hearts, minds and bodies to imaginary creatures so we can discover what being human is all about. They risk staining of their soul by being spiritual vagabonds—living one day as the depraved sinner and the next as virtuous saint. What a rich life I have because I spend it working with the brave child-like beings who have chosen this art.

Whether you are an actor, teacher, or director, you are interested in ways to help actors master their craft. I hope you will find the games and exercises in this book useful. May they help you lead your actors to their truth. It is a tender flock we shepherd. I wish you patience, wit, persistence, nerves of steel and the inspiration of angels.

—Anita Jesse

Contents

Part One

Take Me To Your Leader

"What sculpture is to a block of marble, education is to an human soul."

Joseph Addison
Spectator no. 215

Take Me To Your Leader

Over many years of working with actors on a daily basis, I have concluded that games and exercises provide an ideal means for helping actors refine their skills. In combination with scene work, these activities form the core of my program. Because the games and exercises exploit and cultivate the actors' innate skills, they provide a low-stress environment conducive to efficient learning. I wrote this book because I want to persuade you to explore this approach to helping actors master their craft.

Games and exercises offer a solution

Theatre games thrust actors into situations where they are inclined to interact *naturally,* and without self-consciousness. The circumstances of the game make it natural—almost inevitable—for the players to use their bodies and voices effectively, listen well, and strengthen their imaginations. Engrossed in authentic interaction and free of the tyrannical commentator who dwells in their minds, the actors readily learn to focus their attention, not on themselves, but on a doable task. Once they escape the tyranny of their inner critics, the actors are prepared to tell the truth in imaginary circumstances. The actor who has mastered these skills is on the path toward creative and dynamic acting.

Puzzle-like analytical games succeed because they take advantage of the actors' natural curiosity. As soon as they view the script as a mystery waiting to be unraveled, actors are more easily

motivated to commit to a thorough investigation of clues. Game-like exercises allow the players to discover that scene analysis can be a fascinating play of wits and imagination rather than routine drudgery. Eventually, the actors will be motivated to analyze a scene because they want to satisfy their curiosity and because they know it improves their performances, rather than to satisfy an authority figure. The actors will come to understand that the pages they read are not really a play, but only the directions for presenting a play. This realization will help them see that they must use their fact-finding skills and imaginations to fill in the exciting details that will bring the play to life.

I encourage you to explore these games and exercises because they are designed to work with human nature and assist the actor in learning to take risks. While most people thrive on a certain degree of familiarity in their lives, the actor regularly confronts the terror of the unknown. In attempting to reconcile the imaginary reality of the character with his or her own actual reality, the actor faces the inability to predict the outcome of the creative process. That period of reconciliation is fraught with disorientation and apprehension—it is a period where The Beast, the unknown, terrorizes the actor. Improvisational games provide a means by which actors can develop a tolerance for that anxiety. While playing, the actors are regularly thrust into situations filled with the risk of not knowing and eventually they learn they can survive the apprehension. They can even learn to love The Beast and when that occurs they are free to unleash their imaginations and realize their full potential as creative beings.

One of the dominant themes in my work with actors is the necessity for a balance between freedom and limitations. I work fervently to inspire my actors toward portrayals that are intensely personal and boldly unique. On the other hand, I am equally committed to the solemn contract we have with the playwright. I want performances that are fresh, even surprising, but I insist that the players tell the writer's story.

I am determined to "have my cake and eat it too." Therefore, I work hard to establish an environment in which actors can not only identify limitations and master discipline, but acquire the freedom that will allow them to develop into good actors.

Because I want actors to learn discipline, I know I must help them:

- master concentration
- understand scene analysis
- discover the nature of dramatic action
- grasp the true meaning of listening
- attain basic performance skills
- acquire line-learning skills
- develop a sense of theatre community

Because I want actors to be alive in the moment, I also must help them:

- develop spontaneity
- stretch their imaginations
- learn to trust their own creative being
- experience playing action
- improve teamwork
- expand emotional freedom
- explore the joy of taking risks
- develop an internal lie detector that sounds the alarm when there is no genuine interaction

The games and exercises have proved an invaluable tool for accomplishing these objectives and training actors at every level.

I have described some of my favorite games and exercises with a detailed breakdown of my teaching strategies. Some of these games and exercises were developed in my workshops. They are a synthesis of the tactics I was fortunate enough to learn over many years as a teacher, a student, and an actor. Some of the games I have included you will find duplicated in other books, but I have incorporated them here anyway, because I wanted to share my personal spin on these old standards.

While in many cases I have named the source for a game, in others I have not. It is difficult to assign accurate credit for games that have been handed down in workshops, in the process going through transformations and name changes. Those of us who have been teaching many years have lost track in many instances of what we adapted and what we created. In the bibliography, I have

listed sources, and I apologize if I have failed to give credit where it appears I should have.

I have designed this book to work for you whether you are a teacher, an actor who has never before led a group, or a director mounting a production.

The next three chapters explain how to maximize the use of the book in your setting.

Chapter 2, **To The Teacher**, offers ideas for the classroom teacher who wants to use games and exercises to teach acting skills. I have included a **Sample Curriculum**, in the Appendix, to help the teacher develop a program suited to individual needs.

Chapter 3, **To The Actor/Group Leader**, outlines a plan for the actor who would like to organize a group of fellow actors for the purpose of working out together. The games and exercises here enable actors to improve their craft without benefit of a professional teacher or director.

Chapter 4, **To The Director**, suggests ways games and exercises can solve problems from audition to closing night.

As a leader falling into any of these categories, you may want to review the other *leader* chapters. If you are a teacher you probably wear your *director-hat* part of the time, so you will want to take a look at **To The Director**. Conversely, if you are a director, you sometimes are a teacher as well, so you may be interested in **To The Teacher**. As an actor/group leader you are likely to be curious about the notes to both teachers and directors.

A final note

I have worked with actors on a daily basis for many years and the strategies described in the following chapters have made my work increasingly satisfying. I hope these games and exercises will help you reach the creative being in your actors and enable them to produce performances that are filled with spirit and a sense of their own truth. I hope you will enjoy using these games and exercises as much as I have. It is a great joy and privilege to share them with you.

To The Teacher

Whether you are new to teaching or have been at it as many years as I have, you probably spend a great deal of energy pursuing new teaching strategies. It is the nature of the dedicated teacher to be a perpetual student. Acting teachers are no different. We all yearn for more efficient ways to help actors acquire the requisite tools of the craft while nourishing that unique creative spark. Like many educators, I have learned in my search for more effective teaching strategies that people learn most efficiently when they enjoy the activity. Trying too hard to master skills actually inhibits the learning process. After years of working with actors ranging from the most wide-eyed beginner to the most seasoned professional, I have found these tactics help keep me passionately involved in my work.

These games and exercises will work for your actors

In my workshops in Los Angeles, I rely heavily on these games and exercises for training actors at every level. The workouts, in combination with scene work, form the heart of the program for beginning and intermediate students. The games and exercises serve as ideal warm-ups for scene work in the *pro* classes, and seasoned actors often gain invaluable insight into their process while playing the games.

Beginning and intermediate actors

If you work primarily with beginning and intermediate level actors, these workouts can make an invaluable contribution to your program. At that level of instruction, your goal is to furnish the actors with a solid foundation which will eventually support more refined skills. You are struggling to help them grasp the importance of fundamentals such as: concentration, imagination, listening, and relaxation. You know all too well that they must learn the principles of scene analysis, understand and be able to play dramatic action, comprehend the meaning of characterization and discover how to learn lines effectively. Unfortunately, most actors don't find these goals glamorous enough to hold their attention. The actors are impatient to get to *the good stuff* such as: being in front of an audience or reading good reviews.

The games and exercises I have described provide a shortcut for teaching these unglamorous elements of acting. The actors learn while having fun. What is more important, they learn quickly because they are more apt to be free of the mentally crippling tensions that often accompany learning situations. The actors are acquiring massive amounts of information, but during the playing they are too busy to notice—they are having too much fun to think of it as learning. Certainly, one doesn't have to be laughing and having a good time to learn successfully, but when people are enjoying themselves they are more apt to be open to new information. Learning is serious business, but it need not always be solemn.

Advanced level actors

If you work with actors who are on an advanced level, these games and exercises will serve several purposes. First, you may be dealing with more experienced actors, but you will continue to confront familiar issues. The more advanced actors struggle for mastery of basic skills, albeit on a more sophisticated level. In so many ways, the learning process more closely resembles a spiral than a ladder. One continues to confront weaknesses in the fundamental skills, although one is farther up the spiral. For example, the advanced actor has most certainly moved beyond basic

training in the mastery of concentration. However, farther up the spiral, the slightest flickers in concentration will plague the performer. Same problem, but higher stakes and less leeway for error. Next, these workouts will help you break through old and rigid blocks to creativity that actors often acquire along the way to mastering their craft. Finally, what many professional actors are missing most is a sense of joy in the process. Playing these games may help the actors rekindle that joy.

Freeing the child

The games are an ideal way to break up patterns of self-doubt and blame. Even if you are dealing with an adult, when you deal with the creative human being, to some extent, you deal with the child in that individual. In many cases, that *child* has been cowed by years of verbal punishment for shortcomings. Many actors, even the youngest beginners, are already experts at beating themselves up emotionally for their failures. These games and exercises can help free that fun-loving, still-learning child in your actors.

Tips for using these activities in your setting

Balance the work

I have organized the games and exercises into two parts with theatre games in **Part II, On Your Feet**, and analytical exercises in **Part III, In Your Seat**. However, that organization is only for easy reference. I don't recommend that you work your way through the activities in that order. While there is considerable overlapping of skills developed by the types of activities, moving back and forth between the types of work will provide the most balanced approach. (For a detailed discussion and illustration of this point, see the **Sample Curriculum** in the Appendix.)

Because the analytical exercises will help your actors learn basic scene analysis skills, you probably will want to use them early on. Whenever possible, it is useful to link the analysis

session with scenes from a scene work unit immediately following. Give the actors an opportunity to put their new skills to work as soon as possible.

The more playful games offer an excellent opportunity to turn a group of relative strangers into a cohesive unit. That makes the games ideal for use at the beginning of a new semester or quarter. These activities also make excellent warm-ups—serving to bring the actors' focus to the here and now. I use them in the first few minutes of a class to help the actors slough off their workaday world. These games are also useful when actors have turned scene analysis into brain-lock. A couple of minutes of a game may relax the actors, distract them from the problem and allow them to acquire a fresh perspective.

In my workshops, for example, I may begin with an analytical exercise, follow with a physical warm-up, then segue into the scene work. After some experimentation you will find many useful combinations. The **Sample Curriculum**, in the Appendix, will help you use these games and exercises to your best advantage. I hope it will prove useful in your program.

Enjoy!

In a remarkably short time, these workouts can produce profound changes in your actors' performances whatever their level of expertise. Instead of spending all the class time on scene work—time your actors *may* use to calcify bad habits—devote some time to games and exercises. Take advantage of the opportunity to thrust your actors into situations that exploit and cultivate their innate skills.

I hope these games and exercises will have an impact on your teaching similar to the effect they have had on my work. Training actors is demanding work and, like any teaching, a massive responsibility. I offer these strategies in the hope that they will make your burden lighter and the journey a little more pleasurable.

3
To The Actor/ Group Leader

The actor who doesn't act regularly is flirting with disaster.

Skills, unused, will deteriorate.

Confidence, untested, will erode.

Sign up for a workshop, find yourself a play, or perform on street corners.

But as an actor you must act, for your art thrives only in the crucible of performance.

Are the games and exercises right for you?

As an actor, you know that you learn to be a better actor by acting. However, it may not always be easy to find opportunities to practice your craft. If you had unlimited power you would get every role for which you auditioned, right? However, since you probably don't get every role you go up on, you may be hungry for more opportunities to act. You are probably looking at this book for that very reason. You may be intrigued by the possibility of adding a few more hours of acting to your weekly schedule.

If you are an actor solid in your craft and auditioning regularly, I hope you get cast every time you audition. If you are still learning your craft, my most fervent desire is that you find a teacher who will nourish and invigorate the artist in you. In the meantime, my work with actors in Los Angeles has proved to me that the games and exercises in this book can make a profound difference in an individual's understanding of the craft. I hope you will have an opportunity to explore them. You may wish to join forces with a group of fellow actors to explore these games and exercises. Several factors may persuade you to consider forming such a group.

As an actor currently pursuing a program either in an educational institution or in a workshop situation, you may feel you aren't getting as much opportunity to work as you would like. You may have too few classes per week, classes that aren't long enough, or too many people in the class to suit your appetite. Perhaps at the moment, you aren't able to be in an acting class at all. Perhaps you are *between workshops*.

You may be part of a community of professional actors who work semi-regularly. Between projects, you may want to get together to keep your skills sharp.

You may be part of a group of actors who is preparing for a production. Perhaps your group hopes to put together a showcase of scenes to introduce yourselves to casting directors and agents. Or someone might have said, "Let's put on a show." You may be looking for activities that will help your group to develop into an ensemble and hone acting skills in preparation for your production.

You may be a member of a drama club. Perhaps you have no acting classes in your school and it is up to your group to organize acting opportunities for its members.

Why these workouts are an ideal solution

Whatever motivates you to add more acting opportunities to your current schedule, these games and exercises offer an excellent solution because they are:

Practical

Your group will not need a theatre, or even a hall. You can meet in someone's living room. All you need is willing participants and a space large enough to accommodate the group. You will need very little equipment. A nominal number of "props" are required for only a few games and exercises. In those cases where "props" are needed, a list is provided at the beginning of the chapter and the items listed are readily available to most groups.

Flexible

Your group can adapt the exercises to meet the needs of the most seasoned pros or the most wide-eyed beginners. Actors with considerable training and experience may want to use the games to rediscover the joy in their work. Actors with little experience can learn as they go. Moreover, each session is essentially self-contained. Actors who miss a session can easily pick up where they left off when they return.

Accessible

It doesn't take an expert to moderate the games. Naturally, not having an expert leader means that some benefits of the work will be missed. However, even with a neophyte at the helm, the actors in the group can improve certain basic skills.

Guidelines for setting up your group

The following guidelines will help you and your fellow actors organize your meetings:

What are your objectives?

First, decide what purpose you want the games and exercises to serve. They could function as:

- **a substitute for classes**

 You and your fellow actors may want to develop a comprehensive training program that will temporarily substitute for classes with a professional teacher. In that case, you definitely should read the chapters, **To The Teacher** and

To The Director. Naturally you shouldn't plan to be without the guidance of an experienced teacher for an extended period unless your group is composed of professional actors.

- **a supplement to classes**
 The games and exercises can be a useful means of adding to the training you are already getting in your classes. In this case, you might find the games in Part II most helpful particularly if you are already receiving training in the areas covered by the analytical exercises.

- **strictly fun**
 You could use the theatre games strictly for fun. Your acting skills will improve—that is inevitable. However, the more playful games in Part II will help the actors in your group reclaim the joy of acting. Stay process-oriented rather than goal-oriented and keep the review sessions upbeat and brief.

Who will be the leader?

For the workouts to be most effective someone needs to take responsibility for leading the games. There are several options for delegating that responsibility. The group could:

- select more than one leader for a single session with each of those actors leading one game or exercise;
- select a new leader for each session with each actor taking his or her turn leading the group through all the activities for that meeting; or
- select a full-time leader.

Consider carefully whether you would be willing to take on the full-time responsibility for leadership. You deserve to have the fun of participating along with your fellow actors. If you do decide to be the full-time leader, don't be trapped into playing the teacher. Eventually some people may begin to resent your directions and this might contribute to the demise of the group.

Make a plan

Maximize the use of your time. Plan your sessions and be certain everyone with a responsibility is prepared.

Choosing activities

Determine, in advance, how you will choose the activities for each session. Don't waste time discussing who wants to do what and why. On the other hand, don't get locked into your plans. Allow for spontaneity. Settle on a means of selection that you utilize each time you meet. For example:

- Appoint a committee in charge of planning the agenda for each session.
- Assign rotating responsibility for selecting activities and ask everyone to pledge cooperation with the designated leader's choices.
- When everyone knows the rules for all the games, try this variation: Write the names of the games on slips of paper and draw slips from a box.

Orientation

Use the brief orientation at the beginning of each meeting to:
- remind everyone that the leader will not be teaching, only moderating;
- remind everyone that no negative criticism of individuals is permitted; and
- clarify the objective of the group if there have been any changes since the last meeting.

Be prepared

Ideally, the leader or leaders should prepare by learning the rules in advance of the meeting. However, don't be intimidated by the prospect of tackling a game as a group. Designate one or more actors to read the chapter aloud to the group; take a moment for any questions that come up; and dive into the fun.

Keep your eye on the ball

If you don't have a trained teacher—or at least an actor with considerable professional experience—leading your group, keep comments and discussion to a minimum. Stay focused on the doing. Much of the learning during these workouts happens on a subliminal level. Trust that process and remind one another to keep your attention on finding the solution to the problem or achieving the objective inherent in each game or exercise.

Ideally, you won't depend solely on these workouts for all your training for an extended period of time. However, if your group makes a commitment to these games and exercises, the work will pay off. The experience can provide you with new insights into your process and help you develop essential skills that are certain to make you more effective performers.

While you should set your sights on excellence in your craft, don't allow ambition to kill the spirit of *play* in the sessions. Place the joy of the work at a high priority. Remember that no one talks about *working* a role—we describe how well the actor *plays* the part. And if you plunge in and commit yourselves to these experiences, be prepared to laugh and cry on a regular basis.

4
To The Director

While each production has it own unique personality, some things never change. Certain difficulties arise production after production. There never seems to be enough time. "If we just had one more week, I think we would have something special." Sound familiar? The first rehearsal when actors work off book is almost inevitably a disaster. Whether you are a veteran or a newcomer to the job of directing, you will face a myriad of challenges when mounting a production. Here are some of my favorite ways to use these games and exercises to deal with those challenges. (For additional suggestions, refer to the **Cross-Reference Chart** in the **Appendix**. That chart will help you quickly find the games or exercises that are most apt to help you solve a particular problem.)

Coping with some typical director headaches

Audition shortcuts

The challenges begin long before rehearsals start. There never seems to be enough time for casting. In some cases, you find yourself almost overwhelmed by the number of actors seeking parts. While it's wonderful to have a large talent pool, it's awful to feel rushed. There is that nagging feeling that a gem may slip through the cracks. To get as much information about the actors

as you can, in as short a time as possible, use theatre games. This tactic allows you to quickly gather valuable information on a large number of actors and will help you identify the actors who are adept at basic acting skills.

Games from **Playing Catch** (Chapter 6) and **Magical Machines** (Chapter 10), for example, will help you determine immediately which actors:

- excel at concentration skills
- know how to listen
- are uninhibited enough to be spontaneous
- have enough confidence to take risks

In most cases, the games should not supplant readings. Instead, use the games to glean useful supplemental information that will help you in the elimination process. This information can be used at both ends of the audition process. In the beginning, it will help you weed out the actors you cannot consider. At the other end, use the information in those troublesome tie-breakers.

How do I warm them up?

Sometimes the toughest part of the rehearsal is getting the actors focused. Unless you are directing in a professional situation, you are working with actors who have busy and demanding lives away from the theatre. Sometimes the actors are listless and you need to bring them to life. Other times they are hyper or distracted. It's helpful to have tools for bringing the actors together and focusing them on the work. Choose your tactics based on how long you have worked with the cast and their level of experience. This chapter contains some suggestions to get you started. Check the chart for more ideas.

Let's say the group has no energy—they are distracted and not ready to work. If you are in the early stages of rehearsal and this group has not worked together before, try a round or two of **Sound-Ball** (Chapter 6). If the cast has been together for a while and already knows **Sound-Ball**, lead them through **Bending The Rules** (Chapter 14) or **Sing-Along** (Chapter 15). These lively activities will get the blood pumping and the brains functioning.

In some cases the problem isn't lack of energy, only lack of focus. When faced with a raucous group that is not ready to settle down and work, use a game to help the actors direct their attention to the job at hand. You might try **Daydreaming** (Chapter 18) or **Symphony of Sound** (Chapter 7) to get them still and focused. Follow up with **Group Juggling** (Chapter 11) to help them direct their energy outward. These activities, which supply the actors with a clear point of focus, will help them deposit the workaday world outside the theatre door.

They keep dropping lines

"I knew these lines when I ran them at home." That is little comfort when the run-through breaks down time after time. The most disquieting instances are those where you know that the poor actor who claims to have known the lines earlier is telling the truth. While it is unfortunately true that some actors will come to rehearsal unprepared, more often the problem is *ineffective* preparation.

Often the actor drops a cue because he or she has not connected that line to a thought or action preceding it. There is no *lever* or *spring* that sets in motion a thought process that would logically summon those words. Take the struggling actor through the scene and help him or her identify the triggers. (See **Finding The Triggers**, Chapter 22.) When the actor has installed reliable triggers those memorized lines will pop right out on cue.

The actors aren't listening to one another

During the casting sessions you were careful to cast actors who knew how to listen. These same people were listening to one another in the early rehearsals. What happened? Somewhere along the way the actors switched to automatic pilot.

Experiment with some listening games to jolt your cast into a state of awareness. Choose a problem scene and ask the actors to **Listen Out Loud** (Chapter 17). If the problem is prevalent throughout the cast, involve them all in **Sound Ball** (Chapter 6) then segue to **Group Juggling** (Chapter 11). Many of the games

require listening skills—check the **Cross-Reference Chart** for more ideas.

They aren't concentrating— they keep dropping out of character

When working with inexperienced performers one frequently deals with actors who regularly drop out of character. The problem occurs either because the actors have not learned to concentrate or because they aren't sure where to place their concentration. Many actors simply lack concentration skills and nothing you do is going to make much difference unless you help these individuals develop competence in this area. Whether or not you can deal with this instructional challenge *and* successfully mount a production is doubtful. This is another reason for testing concentration skills during the audition process. If you find yourself in a situation where you must address both challenges, check the **Cross-Reference Chart** for several games designed to build concentration skills.

Sometimes even actors who do know how to concentrate drop out of character—usually because they aren't always sure *where* to focus attention. The misguided actors may be focusing effectively, but on the wrong targets. Attention may be misdirected to line readings, blocking, emoting, or audience response.

Remind these individuals that character is revealed by playing action and action arises out of need. Therefore, the actors' attention must be directed toward character needs and objectives. The actors need to fulfill these obligations *and* remember lines, execute blocking and remain emotionally available. Consequently, they must comprehend the difference between center of awareness and peripheral awareness. They need to know that it is possible to move an object of concentration from the foreground, to the background, and back to the foreground at will.

When the actors are clear about this process, you can help them understand that remembering lines and executing blocking need not be ignored. They are simply moved to the periphery of awareness while character needs occupy the foreground of awareness.

Use games such as **Symphony Of Sound** (Chapter 7) to strengthen the actors' concentration skills and provide some experience in selecting the target of attention. Check the chart for several workouts that will help you drive home other points I mentioned such as action, listening, concentration, and character needs or intentions.

There are no builds—it's all flat

Often when you work with inexperienced actors you watch them play a scene that should build to a climax but continually falls flat. **Can You Top This?** (Chapter 13) is an excellent tool for helping the players internalize the dynamics you want in the scene. This workout will focus the actors on the kind of listening they need to incorporate into the scene. Although the exercise will often be comedic in tone, the essential action of topping or going one better is fundamentally the same in a dramatic scene. This workout will help the actors understand they do not need to manufacture a build—the writer has taken care of that. The actors need to *allow* the scene to build and they can accomplish that by listening and understanding the action of the scene.

You might try focusing the actors on their needs with a few minutes of **I Want You To** (Chapter 9). If the actors are trapped in patterned line readings and obligations to certain emotional responses, this tool will reconnect them with the reciprocal action and free them to listen truthfully. Check the **Cross-Reference Chart** for more suggestions of workouts that sharpen listening skills and teach actors to play action.

They are all working so hard, but there is no ensemble

Perhaps you have a collection of hard-working actors—each with much to offer—but you still don't have a play. The actors know their lines and blocking; the characterizations are promising; the piece moves well; *but* each actor is still working alone. Some of the games are particularly useful for creating that essential sense of connectedness that finally makes this theatre.

Symphony of Sound (Chapter 7) is particularly effective for promoting this feeling of oneness. I also find that actors usually

comment on the experience of ensemble after **Tell Me A Story** (Chapter 12), **Magical Machines** (Chapter 10) and any sessions of **Bending The Rules** (Chapter 14). Check the **Cross-Reference Chart** for additional suggestions.

There are plenty more where these came from

If you are an experienced director you know this list of challenges only scratches the surface, and, if you are new to the job, hold on to your hat. The difficulties in mounting a successful production are legion and just when you work out one kink another appears. In spite of the sometimes overwhelming obstacles you face as the director, you must persist in the problem-solving mode. It is not enough for you to point out what is wrong. Your job description includes providing solutions to the actors who are at least as frustrated as you are when a piece isn't going well.

The examples here are intended to give you an idea of how this collection of games and exercises can assist you in creative problem-solving. The **Cross-Reference Chart** was created to serve as a tickler file. I hope this book can help make the task of molding a production a creative and fulfilling experience.

How To Use This Book

If you read **Take Me To Your Leader**, you already know how passionate I am about the use of improvisational games and exercises and why they form a crucial part of my actor training program. On a regular basis, I watch actors experience remarkable breakthroughs that come as a direct result of these workouts.

Because I am eager to convert you to this approach, I wanted to give you more than a list of games and their rules. I have included guidelines that should enable the most accomplished or the most unseasoned user to successfully use improvisational games as a tool for helping actors develop their skills. I hope those of you who already use games and exercises will find some fresh insights and helpful hints in the following pages. If you have previously experimented with theatre games, but are not yet committed to them as an effective tool for teaching acting, perhaps this book will open your eyes to new opportunities. I also tried to make this work accessible to the individual who might never before have led improvisational games. Whoever you are, I hope this book will persuade you that a large part of learning can be playful, natural, and relatively pain-free.

Basic guidelines

Balance the activities

The games and exercises are organized in two sections:

- the more physical and playful games in Part II
- the more analytical exercises in Part III

While this organization provides easy reference, this is not a recommendation for the order of use. The analytical activities in Part III are essential for helping actors learn to break down a scene; however, a constant diet of this work leaves the actors prone to *paralysis by analysis*. The more playful games in Part II will provide counterbalance—thrusting the players into circumstances that get them out of their heads and into their bodies. You may be surprised by what actors learn in the contrasting activities. For example, it's obvious that actors will stretch their imaginations in the more playful games described in **Part II, On Your Feet**. However, when the subject of imagination comes up, my actors inevitably single out **Treasure Hunt** in **Part III, In Your Seat** as a favorite. Although this game is less playful and more analytical, it helps them to develop confidence in their imaginations.

Repeat games often for maximum benefit

These workouts will eventually produce remarkable results; but it takes time for the actors to become completely comfortable with each game and to start taking chances. Gradually, your actors will overcome their fear of failure and abandon themselves to the activity. Repetition is definitely the key to success.

An overall view

Each of the games and exercises includes:
- a breakdown of the payoffs for playing the game
- a detailed description of the rules for the game
- guidelines for coaching the players
- a blank space for your notes
- a review of the problems you can anticipate
- guidelines for leading a group discussion after the activity

Following are some tips for using this book. These guidelines will help you implement and get the most out of the games and exercises in your setting.

The payoff:

For each activity, I have listed the payoffs. These are the skills and techniques in which the players will develop competence as a result of participating in that game or exercise. As the actors become more proficient in these areas, they will play the games with greater purpose and pleasure. These elements also are the *nuts and bolts* of good acting. The big payoff for the activity is that eventually the actors will intuitively transfer those skills and techniques into their scene work.

This list will help you introduce the activity to the actors. The first few times you use each game or exercise point out these skills before beginning the activity. Knowing that the activity ahead directly relates to their scene work does not detract from the fun. On the contrary, the actors appreciate knowing that while the games and exercises may be playful, they have a practical purpose. The enthusiasm for the activities increases when the actors see that in addition to having fun they will develop the skills they need to present compelling scene work.

The list will also guide you in "Coaching The Players." Clarifying, in your mind, the relationship between your coaching comments and the payoffs will help you be a more effective leader. Keep in mind, however, that in most cases the payoffs themselves will *not* prove to be effective for side-coaching. They are apt to promote self-awareness and the very result-oriented kind of work you are trying to discourage. For example, although you want actors to enhance their listening skills while playing several of the games, you don't want them to focus on listening itself. Instead, you want the actors to focus on what they are asked to listen to.

Use the payoff list to help you lead the group review after the activity. When you get to "Tell Me Again Why We Played This Game," it may help to *prime the pump*. Mentioning the skills listed for that chapter will stimulate the discussion.

You will also find the payoff skills listed on the **Cross-Reference Chart** in the appendix. This chart will help you find the exercises best suited to address the specific needs of the group. For example, if a large number of actors are struggling

with listening skills, check the chart for recommendations. When you find *listening* on the chart, you can readily identify the games and exercises that help actors learn to listen more effectively.

How to play the game:

Every effort was made to provide you with simple and useful rules for each game and exercise. However, don't be intimidated if you can't fully visualize a game before playing it. Submit the rules to the players, as written, and you will be amazed by the effectiveness of group intelligence. Each person learns from the other and everyone will contribute to the process of understanding the game.

For each game I have mentioned the ideal number of players. You may need to split a large group into smaller groups and play more than one round.

For several of the exercises the actors work with scenes. If all the players read the full script before working on a scene, the analysis will be far more effective. However, the actors who are focusing on preparation for film and television careers should occasionally practice analyzing a scene *outside* its context. In television particularly, actors frequently do not get a copy of the entire script before the audition. Yes, the Screen Actors Guild recommends that the actor should have access to the script twenty-four hours before the audition. However, in the real world of production pressures that isn't always possible. Actors who never read the full script before their preparation form the habit of making haphazard choices based on incomplete, even misleading, information. On the other hand, actors who feel they *must* read the entire script to feel confident going into an audition are in equally serious trouble. They will be at a serious disadvantage in the fast-paced and hectic television industry.

Coaching the players:

As the leader of the group—whether you are the teacher, director, or actor/leader, you will offer valuable coaching to the

players. In some games or exercises you will give most of your helpful hints before the activity (**pre-game coaching**), then offer brief reminders (**time-out coaching**), during breaks or natural transition periods. In other games, coaching while the actors work (**side-coaching**) is most useful.

In some of the activities you aren't strictly coaching—you are offering continuous guidance. A couple of the deep relaxation and concentration exercises, such as **Daydreaming** (Chapter 18) and **Symphony of Sound** (Chapter 7), call for the leader to lead the players, step-by-step, through the experience.

I have included examples of coaching for each of the games and a brief explanation of what each coaching phrase means.

Pre-game coaching

These are the notes you give the actors before the game that help them implement the rules.

Time-out coaching

As I mentioned earlier, in some games and exercises you will do most of your coaching during natural breaks. For example, there will be a break *after* Pair #1 finishes their first version of the **Eight Line Scene** (Chapter 20) and *before* they begin their second version. In other cases, you will need to interrupt the activity to give actors their notes and get them back on track.

Side-coaching

Occasionally, you will give your actors side-coaching. In this case, you give the actors direction *while* they work, sometimes talking over the actors. They hear your side-coaching without interrupting the play to ask for clarification. Train the players to use *peripheral hearing*. A driver can focus on the road ahead and use peripheral vision to note movement out of the corner of the eye. In much the same way, the players can focus on their tasks during the theatre game and still hear your side-coaching.

When side-coaching during group activities, avoid coaching by name, since this may cause self-awareness.

Add your favorite coaching comments or notes here:

You will eventually devise coaching comments specific to your needs. In some cases, you will want to jot down notes that remind you how to most effectively lead the group in the activity. Blank space is provided for you so you won't end up with all those little pieces of paper that keep falling out of the book! Just remember to keep your side-coaching comments brief, positive, and filled with verbs.

Watch out for the traps:

Although there is a certain amount of overlapping between "Coaching The Players" and "Watch Out For The Traps," they serve different purposes. "Coaching The Players" supplies directions that you, in turn, give to the players. "Watch Out For The Traps" is intended more specifically for you, the leader.

I wrote these notes for you because I know that, in spite of your best efforts at coaching, some actors will struggle. For each game or exercise, I have described some of the thorny problems that crop up time and again. These are the things that will leave you pulling your hair out, and muttering, "Why do they keep doing that?" Don't be discouraged by these lists. Thoroughly acquaint yourself with this section before the work. A clear picture of the potential problems will help you keep the players on target. Forewarned is forearmed.

Tell me again why we played this game!

This is when you discover whether the actors are successfully connecting the work in the game or exercise to their craft. Always lead your actors through a review of the activity, asking them to comment on what they experienced during the workout that applies to their acting. The first few times you hold this debriefing, you will need to lead the actors, point by point, through the

connections between exercise and craft. Eventually, your players will amaze you with their insights.

Examples from my actors

I included sample comments from my students to help you guide your first couple of review sessions. Some of these comments are almost direct quotations, but most are a combination of several remarks. Note how the comments inevitably wrap back to the skills listed in "The Payoff." Originally, the relationships described in these comments were connections I pointed out to my actors. Later, when they fully grasped the relevance of the exercises, the actors personalized the observations. Use these comments to help you steer your actors toward an understanding of the link between the exercises and their on-stage work.

No student faultfinding

I never allow students to point out what is lacking in another actor's work. Actors need a bond of trust with their leader and among themselves if they are to risk exposing themselves through their work. It is difficult to maintain that bond if the actors are subject to either real or imagined ridicule from their peers. On the other hand, actors grow as a result of articulating what they experience during these workouts. Pinpointing the elements of their experience helps the actors organize their thoughts. Therefore, I ask my actors to share what they experienced during the activity and to comment on what they observed in other people's work.

Focus on what works

I circumvent negative criticism by pressing the actors to recognize what makes scene work exciting and entertaining for the viewer. I ask them to point out specifically what they saw in the game or exercise work that they want to see carried over into on-stage work. Never are the actors permitted to point out what a classmate *should* have done. I take responsibility for all negative criticisms. The actors are asked, instead, to identify the elements that *succeeded* in engaging us. Refer the actors back to the points listed in "The Payoff" such as: listening, interaction, concentration, spontaneity, use of bodies and voices, and emotional range.

Guiding this investigation provides you the ideal opportunity to help actors master the fundamentals of good acting. As a matter of fact, one of my primary motivations for writing this book was to convince you to incorporate a discussion after the playing of each game. Just as important as the playing is helping the actors understand how those games and exercises relate to their acting. If they consider a game a time-killer, they will rapidly lose their enthusiasm for the playing. Conversely, if they understand that the workouts help them develop competence in areas that in turn translate into vigorous performances, they will commit themselves to the activity. On innumerable occasions, I have seen actors make their biggest breakthroughs in their understanding of the craft, not while working on a scene, but during the review of a game just played.

Gradually condense the review period

After the actors have been playing a game for a while, you may want to condense the discussion period for that workout. As the players become more familiar with a game, it will eventually serve as a warm-up for newer games, or for scene work. At that point, you may want to devote the bulk of your review session to the newer activity. You also could have your actors play two or three familiar games and consolidate the discussion period.

Want more information?

While the games and exercises in this book stand alone, I refer you to my earlier book *Let The Part Play You* for additional information on the topics covered here. In *Let The Part Play You* many of these subjects are discussed at much greater length. I have also included in the **Appendix** a bibliography of other sources you may find helpful.

Let the games begin!

Part Two

On Your Feet

Though this be madness, yet there is method in 't.
William Shakespeare
Hamlet, Act II, Sc. 2

#6
Playing Catch

The games in this group are my favorite warm-ups. Since there are very few traps, the actors will immediately experience a great deal of success and that success quickly builds confidence. These are excellent games for creating a sense of unity among actors. In addition, if you have a group of people who are taking themselves too seriously, these games will loosen them up a bit.

All the games in this group are based on **Sound-Ball**. The variations were created by my actors while playing **Bending The Rules** (Chapter 14). **Sound-Ball** is a popular theatre game. I learned it from Lynda Belt and Rebecca Stockley's excellent book, *Improvisation Through Theatre Sports*.

The payoff:

- **Getting actors out of their heads and into their bodies**
- **Listening**
- **Relaxation**
- **Vocal warm-up**
- **Physical warm-up**
- **Interaction**
- **Spontaneity**
- **Ensemble**
- **Concentration**

How to play the game:

1. Sound-Ball

A large group can play this game. The number will depend on the size of your space. The players stand in a circle with comfortable elbow room. Create an imaginary ball—it should be approximately basketball size so the players use both hands catching and throwing. Have the players toss this imaginary ball back and forth for about a minute, then add the sound element. The first player tosses the ball to another player *and* sends a sound with it. When the second player *catches* the imaginary ball, he or she repeats the sound that was sent with the ball. Then that second player throws the ball along with his or her new sound. The game would sound something like this example:

Player #1: "Whoosh"—as he throws the ball.

Player #2: "Whoosh"—as she catches the ball. "Yow"—as she throws it.

Player #3: "Yow"—as he catches the ball. "Uhh"—as he throws it.

Player #4: "Uhh"—as she catches the ball. "Waah"—as she throws it.

(The players are not numbered; they throw at random to each other. Nor do the players say words; they make noises. In the preceding example, I have described the type of sounds the players might improvise.)

You could play this game with a real ball, but I strongly encourage working with an imaginary one. A real ball injects the possibility of failure. When someone misses the ball, the flow of sound will be interrupted. More importantly, it sets up the temptation for players to beat up on themselves for their mistakes. With the imaginary ball, no one ever misses and the participants have an opportunity to lose themselves in play.

When the players are comfortable with this game, they will respond physically as well as vocally. They will transform the imaginary ball into varying sizes and make it alternately heavier

and lighter. Not only will they *catch* the *pitcher's* sound but their bodies will reflect the impact of catching the imaginary objects.

For example, Player #1 *throws* "Argh!" and strains to hurl an imaginary ball that is big and heavy. Player #2 falls to his knees catching the massive object with an answering "Argh!" Player #2 then transforms not only the sound, but the physicality as well. Player #2 may throw a tiny ball, light as a feather, with "Whoosh." This increased physical involvement frees the players to produce more intricate and more uninhibited noises. In turn, the sillier the sounds get the more physical the game becomes.

2. Look, Ma, No Hands

The players propel the imaginary ball across the circle with any part of their bodies *except* their hands. For example, they might kick it, bump it with a shoulder, or push it with their noses.

3. Three Part Sound-Ball

Instead of making a simple sound, each player creates and repeats a sound with three parts. For example, instead of "Pow," the player would throw "Pow, zing, mmm." The next player would repeat those three parts and respond with three new ones.

4. Sound Tag

All the players close their eyes, except for the player who is *it*. Everyone extends a hand ready to receive a sound. The player who is *it* begins a continuing sound, moves around the circle and tags someone by *handing* that person the sound. The second player opens his eyes and repeats the sound, just as in **Sound-Ball.** Player #2, now *it*, moves (eyes open) across the circle, transforming the sound into his or her sound, and *hands* the new sound to Player #3. Once the sound is passed on, the person who was *it* takes the tagged person's place in the circle and closes his or her eyes.

Players who are self-conscious get a major bonus from this game. Because no one is watching, they don't have to face the fear of being judged. The freedom to fail without witnesses empowers these players to take risks and to be more spontaneous.

5. Sound Chain

The first player throws sound and movement to a second player. That player throws the sound and movement received followed by his or her new sound and movement to a third player. Player #3 catches both of those sounds (with accompanying movements), then throws those two sounds (with movement) followed by his or her new sound (with movement). Player #4 catches all three sounds, then throws those three along with the new sound. Before long the players will begin to lose track of all the sounds and movements and things will get pretty wacky. Allow the game to continue even if the repetitions are not perfect. Encourage the group to enjoy their mistakes and keep the chain going as long as possible. While the aim is accuracy of repetition, this game must not be taken too seriously.

6. Living Sound-Ball

The players *become* the ball. The first player repeats a sound accompanied by movement while crossing the circle to face another actor. That second player begins to mimic the first player's sound and movement as the two actors exchange places. Player #2 then moves out into the circle repeating the sound and movement. While making his or her way across the circle, Player #2 transforms the sound and movement into a new noise and movement. Then, he or she selects a third player and passes both sound and movement to that player.

Coaching the players:

Rely mostly on side-coaching for this game. These reminders will help keep the players on track.

"Play, don't analyze."

Encourage the players to throw the ball and their sound *before* they have time to think about it.

"Stay in the moment."

The players should keep their eye on the imaginary ball and their ear on the sounds they are given. Their attention must not be

directed toward preparing a sound they *might* contribute when the ball comes to them.

"Use your whole body."

A few actors will try to play using only their arms. Urge them to involve their whole body in these games.

"Keep the ball moving."

When the players pick up the tempo, they will have less time to think themselves into trouble.

"Pay attention to the ball."

Some of the players may *drop out* until someone throws to them. They need to recognize that this is the equivalent of starting a race *flatfooted*. Urge the player to stay in the game from beginning to end and to listen not just with their ears, but with their bodies as well.

Add your favorite coaching comments here:

Watch out for the traps:

A few of the participants will want to think about a sound before responding. Urge them make a sound *before* they have time to think about it. There is no need for a censor in this game. How could a sound possibly be *wrong*?

The beauty of these games is that there are no serious traps and it's relatively easy to get a group involved in them. You will find that the more they play, the sillier and more inventive the group gets and the more fun they have.

Tell me again why we played this game!

"It was great to have that sense of being *in my body* instead of all tied up in my head—criticizing myself. Every time we play this game, I get more comfortable focusing my attention outside myself and that is helping me in my scene work."

"I had so much fun! It's liberating to play—to be silly! It surprised me that being silly didn't interfere with my playing. It felt great to stop watching myself. I gave up trying to see if I was making a fool of myself."

"These games are helping me understand what it means to have a point of concentration. You really have to pay attention to the sound and movements. You don't have time to think about other things."

"I love the spontaneity and freedom of these games. It makes me understand that it's the self-judgment that inhibits spontaneity. That self-judgment is exactly what keeps me from being as open as I want to be in a scene."

"I am so alive when I am playing these games—so free. I want that kind of vitality in my scene work!"

"I want to listen during a scene the way I listen when **Playing Catch**. I want to have that same sense of being in the moment. I want to remember that I can respond with my lines without stopping to think about how I am going to sound saying them."

"These games have helped me understand relaxation. I was really nervous when we started playing, because I'm not good at ball games plus I couldn't imagine what sounds I could make. But, the more I concentrated on just playing, the more I relaxed. By the end, I was having fun and surprising myself."

"I'm beginning to understand that interaction is something you *feel* in your body."

"I loved being part of the group action. After a while, there was a terrific sense of momentum and we were all functioning like a well-oiled machine. Then I experienced this wave of confidence that I wasn't alone and didn't have to struggle. This experience showed me the meaning of ensemble."

#7
Symphony of Sound

Use this exercise to guide your actors to a state of deep relaxation. It offers an excellent opportunity for enhancing many essential skills and it will become a favorite of the group.

The payoff:

- **Listening**
- **Concentration**
- **Relaxation**
- **Ensemble**
- **Vocal warm-up**
- **Getting actors out of their heads and into their bodies**
- **Spontaneity**
- **Imagination**

How to play the game:

When possible all the actors should participate. However, a group of fourteen or fifteen is the optimum group size. The actors stand in a circle with comfortable elbow room. Walk around the circle, speaking in a soft, even tone as you lead the players—step by step—through the experience. Be sure to leave silences

permitting the players an opportunity to focus on sounds other than your voice. Use the following narrative to help you *conduct* your first *symphony*. Notice that comments to you, the leader, are in brackets. These sections are not to be spoken aloud to the group.

Conducting the symphony

Close your eyes. Drop your arms by your side and focus on your breathing. Simply observe your breathing. Don't try to improve it in any way; just keep your breathing at the center of your awareness. Use your imagination to help keep your attention on your breathing. Imagine breathing not just into your lungs but into every part of your body. Add a visual element. For example, imagine inhaling one color and exhaling another. Inhale a color that you find relaxing. Then exhale a color that represents tension. Locate the tensions in your body. Now, imagine the exhaled air carrying tension out of specific muscles while the inhaled air soothes and relaxes those muscles. Imagine specific muscles being massaged by the breath.

Now that you are deeply relaxed, shift your attention to listening. Pay attention to all the sounds you can hear—the breathing of the person next to you, the hum of the air conditioner, water running, a bird chirping outside, a car engine. Keep searching for sounds you didn't hear at first but can detect by listening more carefully. You are a listener—soaking up all the sounds, never analyzing, never labeling, only listening.

Mind-surf the sounds in your environment. Allow first one sound then another to occupy the center of your awareness.

[*Allow the actors a period of brief silence.*]

Select a sound and move it to the center of your awareness. Hold that sound in the foreground, allowing all others to recede to the background.

[*Allow the actors a period of brief silence.*]

Select a different sound from the background and bring it to the forefront of your awareness. Hold that sound in the foreground, allowing the other sounds to slip into the background.

[*Allow the actors a period of brief silence. Repeat this instruction to move the sounds from foreground to background and back again a few times. Allow the actors time to develop confidence in their ability to control the focus of their concentration.*]

Invite what you hear to reverberate inside you. Get it into your body. Put yourself inside the sound. You find yourself losing track of where the sound leaves off and you begin—where it stops and you start. You are in the sound and the sound is in you.

[*Allow the actors a period of brief silence.*]

Notice that the noises in the environment create a sound improvisation—a sort of environmental jazz with intricate themes, rhythms, and varying tempos and volumes. Listen to the *music.*

[*Allow the actors a period of brief silence.*]

Add your sounds to the improvisation. You are not expressing ideas, so you aren't looking for words. Remember the free, creative noises you produced when you played catch. Use your voice now in the same non-judgmental manner. Bounce your sound off what you hear—improvise with the environmental jazz. Continue to listen as you improvise. Free the sound *symphony* inside you. Your body and voice are free. You produce all types of noises: mechanical sounds and animal sounds; sounds like the wind and sounds like the ocean; wailing or cooing sounds; blowing or thumping sounds; sweet and shrill sounds. Any sort of noise may come out of you. Your sound fills the room. Surrender to the *symphony of sound.*

[*You may need to contribute some examples to lend confidence and lead the way.*]

Imagine the *symphony* resonating in your back, in your shoulders, and in your legs as well as your head and chest. Fill your bodies with your chorus. Fill the room with your resonance.

[*Side-coach the group until the* symphony *fills the space and all the players are fully committed to the*

improvisation. Allow the group to enjoy improvising for a few seconds without any side-coaching before you conclude the exercise.]

Now the *symphony of sound* is sinking farther and farther back into your bodies. Eventually you are silent and once again a listener. Direct your attention again to the sounds outside the circle.

[*Allow the actors a period of brief silence.*]

Concentrate on your breathing.

[*Allow the actors a few seconds to become fully aware of themselves in the room.*]

Now open your eyes, wiggle your fingers and toes, shrug your shoulders, and look around at the objects in the room. Undertake a mental task such as counting the number of blue things in the room, or the number of square objects in the room.

Add your notes or reminders here:

Watch out for the traps:

It's fairly simple to keep the players on track with this exercise; but even in the simplest of games there can be problems.

The first few times the actors play this one, they may be self-conscious about adding their sounds. Talk them through it. Encourage them to toss sounds against the *soundscape* just as they tossed the sounds when **Playing Catch** (Chapter 6).

Some of the actors, afraid they can't produce *commendable* contributions, will hold back. Assure everyone that every sound is perfect.

If a player injects language, encourage him or her to let the sound sink deeper into the body. Encourage the person, then, to allow the word to transform to a non-speech sound. Remind the players that the point of this game is to produce *pure sound* not ideas.

Some of the players may become unfocused and so relaxed they find it difficult to return to the here-and-now. Remedy this by engaging the group in a physical workout. Games from **Playing Catch** are ideal choices.

Tell me again why we played this game!

"I learned a lot about my concentration skills when we were selecting a sound to bring to the center of awareness. I can see that I need to do more concentration exercises on my own."

"This made me realize that I very rarely listen to anything except the racket in my own head. I'm listening to the dialogue tape that I'm running in my mind, instead of listening to what is happening outside of me. I'm determined to become a better listener."

"This was deeply relaxing. I'm looking forward to trying the first few phases—the concentration on breathing and the listening—on my own."

"It was great being a part of the group sound-improvisation. I felt so free and empowered by being part of that ensemble. I know that's what we all want to feel when we are doing a play. We want the whole to be greater than the sum of the individual parts."

"Once again I found that concentrating my attention outside myself helped me be free, to be spontaneous."

"I'm discovering that it is good for me to participate in an activity that doesn't encourage me to analyze. It helps me to be involved occasionally in something that doesn't make sense. When things make sense, I start thinking I have to organize, manage and excel."

The Playing Is The Thing

8
Mirrors

This game is a theatre-game classic. I believe credit for the source usually goes to Viola Spolin. The demands of **Mirrors** are not intimidating even to inexperienced actors and there are comparatively few traps. It is an excellent game for helping actors develop concentration. This is an ideal activity for groups who are just beginning to play improvisational games since concentration is the foundation upon which all other actor skills depend.

The payoff:

- **Concentration**
- **Freeing the body**
- **Relaxation**
- **Getting actors out of their heads and into their bodies**

How to play the game:

Each actor works with a partner, standing—facing one another—slightly less than one arm's length apart. The actors establish eye contact immediately and maintain that eye contact throughout the side-coaching. Assign roles to the players. One actor from each pair is the *mover*, or initiator of action, and the other plays the *reflection*.

Each actor holds both hands at about chest level, palms facing out—toward the partner. The actors move their hands straight forward until the mover's palms are only an inch or so away from the reflection's palms. Direct the mover to begin exploring space with his or her arms, making slow, easy to follow movements. The reflection mirrors those movements. The hands do not have to remain in the original position—an inch or so apart. If the mover moves his or her hand back in the direction of the body, the mirror image should reflect that movement.

When all the movers and reflections are playing their roles successfully, encourage the movers to move not only hands and arms, but their entire bodies. The movers should keep their movements simple enough to follow; they should not try to lose their reflection.

When the pairs are working together effectively, instruct them that in a moment you will call "Switch." At that point, the actors are to switch roles. The objective is to make the transition seamless. The actors should avoid stopping, making the switch, then resuming activity. Ideally, this switching of roles should not be obvious to someone watching from the other side of a sound-proof glass.

When the pairs have solidified their contact, call "Switch" again. Give this direction every ten seconds or so—side coaching between times. After a few seconds of this direction, begin to call "Switch" after about five seconds, then after two or three seconds, and so on. Eventually you should be calling "Switch ... switch ... switch ... switch ... switch" with only a slight pause between calls.

While this game is a simple one, it's a rigorous test of concentration. If the players are to succeed in their tasks, they must become closely attuned to one another. The mover must pay close attention to the reflection—*willing* that player's body into action along with his or her own. The reflection must listen carefully to the mover detecting, and reflecting, the slightest nuance of movement.

The game also is a lesson in surrendering. When playing the reflection, the player must abandon the impulse to create and

allow himself or herself to be guided by another player's creative impulses.

Coaching the players:

Maintain a balance between side-coaching to keep the actors on track and periods of silence during which the actors *listen* only to one another.

"Focus on the doing."

If there is a slight lapse in concentration, the players should put it behind them and redirect their attention to the task. Encourage them to focus on the exploration of space.

"Maintain eye contact."

The eye contact will help maintain the essential communion between the players. At first, some actors may find it extremely uncomfortable to look into each other's eyes. Give them a method for overcoming their self-awareness. Ask them to commit to a task. This task could be as mundane as comparing their partner's eyebrows to see which is higher. All that matters is that they get their attention off themselves.

"Experience, don't judge."

Remind the players to resist judgment and criticism. Movements are neither good nor bad—they simply *are*. This game is an excellent one for helping actors to learn the first principle of concentration—suspension of self-judgment.

"Take ownership of your reflection."

When you see a mover who isn't concentrating, remind the movers to take responsibility for their reflections. Remind them that the mover's point of concentration is to *share* his or her movement while *willing* the image in the mirror to duplicate each nuance. Suggest to the movers that they can't afford to lose their reflection. I sometimes coach: "You can't see what you are doing if your reflection isn't showing you."

"Keep your movements simple enough to follow."

Occasionally, it's necessary to remind the movers not to show off acrobatic skills.

"Listen with your body."

The actors playing the reflection should not be inventing, only following. It helps if the actors think of *listening with their bodies* and allowing themselves to be pulled through space by the movers' impulses.

"Who is the mover, who is the reflection?"

Ideally, an observer, who had not heard the assignment of roles, would find it difficult to determine who is initiating the movement and who is the reflection.

"Go back to neutral if you need to re-connect."

If you see that an actor has lost his or her concentration, remind the players that returning to the starting position will help to re-establish the connection.

Add your favorite coaching comments here:

Watch out for the traps:

Occasionally you will find an actor who can't resist a contest. You may have to side-coach to remind him/her that the objective is for both people to win in this game.

Watch out for the actor who wants to turn this into an intellectual exercise. Help the actors stay in their bodies, rather than in their heads by encouraging them to focus their attention outside themselves. Keep them focused on their partner and on their physical tasks.

Tell me again why we played this game!

"It reminded me of just how critical concentration is for relaxation. I noticed that if I just focused on the doing, on the task, my self-awareness melted away."

"It was exciting to experience that kind of trust and freedom. When I played the part of the reflection, I could really just let go and give myself to the moment. It helps me understand what *being in the moment* means."

"I realized how much time I spend criticizing every thing I do. I kept hearing myself trying to comment on how well I was leading or following. I discovered that, if I just focused on the doing, I could still my inner critic."

"It was so much fun to let go of the need to be 'interesting' or 'good.' I finally got focused on my objective and everything was easier. I want to do that in my scene work."

The Playing Is The Thing

9
I Want You To

Acting is doing. Doing is a product of wanting. When people feel that something is missing, they try to relieve the discomfort of that unfulfilled craving. They say and do things to fix what is wrong or, at least, persuade others to admit that something is wrong. They attempt to end inequities. They share a story because it validates a position they have long held or simply because it tickles their mind and begs to be told. They try to persuade others to give up behavior they find threatening, distasteful, or unethical. They plead for mercy, demand a hearing, or seek a sympathetic ear. They vent frustration, vie for attention, or offer sympathy. They challenge some to battle, urge others to celebrate victory, and invite comparisons of strategy. Most often they don't know exactly what they are doing or why they are doing it. However, that sense of incompleteness continues to motivate *doing*. They are mentally and or physically active—*scratching a psychic itch*.

We expect no less of dramatic characters. We empathize with them because we recognize that they struggle with unfulfilled desires just as we do. The wants and actions vary from one script to another but scene by scene the principle holds true. The first act may open with a sister inviting a sibling to share memories of past glory. Another piece begins with one neighbor asking another to hear her frustration over hurt feelings. In one scene, a father begs his son to forgive him for heinous crimes of the past. In another, a mother warns a daughter to avoid repeating her mistakes. Act II may begin with a husband trying to articulate his

devotion to a beloved wife, or a jury member insisting that peers examine evidence more carefully. One way or another, the needs drive the physical and mental activity that constitute the action. When the principal character has either vanquished the *enemy* or suffered defeat, the curtain comes down or the credits roll.

In this exercise, the players are given *wants*, then they use their imaginations to make those needs personal. If the actors succeed in internalizing these needs, they will be compelled to do and say things to fulfill their desires. The effort to satisfy the desires forces each actor to deal with the obstacles raised by the other actor. Because the exchange isn't complicated by memorized dialogue and studied characterizations, the actors are free to focus all their energies on solving the problem at hand. This produces an ideal climate for a genuine exchange of energy between the actors. The actors have an opportunity to discover the mental and physical actions that are an inevitable by-product of commitment to a need. They are in an ideal position to experience authentic reciprocal interaction. Eventually, actors who have experienced this genuine interaction feel uncomfortable or dissatisfied when they get less than that in the scene work.

Because **I Want You To** is ideal for installing what I call the actor's *lie detector,* it is one of the linchpins of my program. Use it often; it will serve you and your actors well.

The payoff:

- **Understanding dramatic action**
- **Understanding character needs**
- **Listening**
- **Spontaneity**
- **Interaction**
- **Understanding conflict**
- **Emotional range**
- **Concentration**
- **Imagination**

How to play the game:

The actors work in pairs, one pair at a time, in front of the group. Give each actor one line of dialogue to use throughout the exercise. One actor is given a line that includes an explicit need— "I want you to ..."—while the other actor is given a statement that contains an implicit need. For example, we might have *Sue* and *Bill* use these two lines:

Sue: "I want you to tell me what she said."

Bill: "I can't tell you that."

Sue clearly states what she wants. Bill's line doesn't spell out what he wants but implies his need. If Bill stated the implied need he might say: "I want you to understand that I can't reveal that."

No actor conference

The actors are not given time to exchange information before they work. Those conferences frequently do more harm than good. Often the more assertive of the two actors uses the time to intimidate an easygoing partner. The less assertive actor ends up playing out the assertive actor's personal scenario. The assertive actor has switched roles—from actor to director. That switch in roles means a redirection of energy. Less energy is available for playing the here and now interchange because the once-actor now-director is busy directing the activity. Moreover, the easygoing partner may have gotten the message that his or her creative impulses are not to be trusted. They may not fit into the agreement made with *the boss*.

Sometimes the actors negotiate an agreement about circumstances without realizing that their choices have eliminated any motivation for interaction. Before the dialogue begins, one actor may cede defeat and the two players end up *on the same side*. The point of the exercise is to thrust the actors into a situation where each one doesn't have what he or she wants. The wanting produces the doing. The doing is what engages the audience.

Pushing buttons

Before beginning the interaction, the players take a moment and allow the words to trigger in their memories the *who, what* and the *why*. If the actors genuinely *hear* the words—take them personally—they will tap into needs and obstacles. When you explore the sample lines of dialogue at the end of this chapter, you will notice that the "I want you to ..." phrases are familiar expressions of need. Each of us has said these words or had them said to us. Our emotional *buttons* have been pushed by these phrases. Remind the actors to feed off the personal associations brought up by the words.

At first, the past experiences associated with the words will provide the fuel for the action. However, encourage the actors to trust their imaginations. If they internalize the needs and take personally what is said now, the on-stage relationship will evolve. If they commit to the doing, the present time struggle will create increasing urgency. Eventually the here-and-now struggle will produce sufficient emotional heat to temporarily overshadow the past experience that originally fueled the doing. Sue must trust that, here and now, only Bill can help her solve her dilemma. Bill must acknowledge that Sue wants his help and that helping her means he must give up having what he wants.

Stay with the dialogue

The actors should stay close to their assigned dialogue. The focus is on satisfying the objective. The actors shouldn't be concerned about being clever or interesting with words, nor should they try to fill in the details of the story for the audience. The actors are playing the stripped down version of the dramatic action. The audience members will delight in using their imaginations to supply the details.

The ending hasn't been written yet

The players must understand that the ending of this improvisation has not been determined. Sue may give up and tell Bill to get lost; Bill may break down and reveal the information; or you may end the exercise before the conflict is resolved.

Trust actions to produce emotions

The actors shouldn't be concerned about invoking emotions. Emotional responses are inevitable by-products of action. The degree to which a person perceives success or failure in the satisfaction of needs determines how one feels about a situation. The players should focus on satisfying their wants—emotions are a natural consequence of the reciprocal action.

There is no *correct* emotional tone for any of these exchanges. When both players fully commit themselves to the pursuit of their needs they will experience a wide range of emotions. One moment, a player might be howling in a state of rage and in the next second rendered powerless by the rejoinder from the other actor. The person who sets the action in motion with the explicit statement of need may be conciliatory in the beginning then driven to fury by the end. The opposite is equally possible. The individual who sets the action in motion may approach his or her partner with power and confidence in the beginning then eventually be reduced to laughter or tears. The actors should use this exercise to explore their full emotional range.

Physical force isn't the answer

Be sure the participants understand that no physical force is permitted.

Don't give up

You may find this exercise disheartening in the beginning. Just when you have guided the actors through one challenge, another problem will demand your attention. However, I can promise you that it is worth wading through the early discouraging stages. Eventually the actors will discover the power and joy of abandoning themselves to a mission and you will see a parallel difference in their scene work. This exercise will help you communicate the *doing* of acting. While the emphasis in this presentation of the exercise has been on the actor's basic skills, this workout will prove invaluable to you as you help the actors refine their craft.

Coaching the players:

Some guidance for this exercise can be accomplished with brief comments that qualify as side-coaching. In some instances, however, you will have to interrupt the dialogue to help an actor with choices or encourage an actor to take emotional risks.

Try these examples of coaching to keep the actors focused on action:

"Get what you need."

Some people always seem to be able to instigate a truce. "You don't do anything to me and I won't do anything to you." This tactic is useful to an actor who needs to avoid the emotional heat of interaction.

If the actors aren't playing action, remind them to recall their *wants* as stated in the dialogue. In our example, Sue must devote her energies, mental and physical, to getting the information, or suffer the loss. Bill must persuade Sue to give him the peace he craves, or he will suffer the consequences. Urge the actors to vividly imagine what it will be like if they don't get what they want—just as they would do in real life. The consequences of failure must be interesting and unpleasant enough to get the actors' attention and motivate them to action.

"Make it personal."

Some actors protect themselves by making impersonal choices. They unconsciously gravitate toward so-called needs that fail to produce any visceral involvement. A choice may be interesting on an intellectual level, yet so impersonal that it fails to compel one to action. The actors must commit to choices that are simple, heartfelt and plagued with great personal risk. Unless their choices make them want to change things—to end the discomfort caused by the existing circumstances—they aren't useful choices.

"Stay with the action."

You may have actors who insist that this work doesn't permit them to do anything "interesting." Help them understand that if they watch themselves to see whether or not they are interesting,

they take their eye off the target. Distracted by their own image in their mind's eye, they ignore their need.

What will interest the viewers is the drama of two people, each engaged in a struggle to satisfy his or her desires. The audience will mark the tactics used, the results produced by the tactics, and the players' reactions to each victory and each defeat. Encourage the actors to stay with the doing and leave the audience to determine what is interesting.

"Solve the problem, don't *report* on it."

Often actors remove themselves from the dilemma and hide out in the role of reporter. You will know that the actors are merely reporting on the state of affairs when the so-called action seems to go in a circular loop—nothing changes—nobody wins points, nobody loses points.

An actor may avoid the uncertainty of interaction by playing what I call "King of the Mountain" or "Neh-neh, you can't get me!" The actor using this tactic declares victory, leaving himself or herself free to comment on the other person's discomfort while remaining untouched. Sometimes an actor becomes so preoccupied with feelings of frustrations that he or she stops doing and steps *out of the ring* to comment. Remind the players to focus on doing and cope with each other's actions.

"Stay with your dialogue."

There will be minor alterations in the lines once the actors are immersed in the interaction. Don't inhibit these organic changes. However, some people are more comfortable creating dialogue than engaging in reciprocal action. Side-coach actors who direct most of their attention to creating explanatory, *interesting* dialogue.

"Don't lean on the words."

Side-coach when the actors try to manipulate the words into *meaningful* line readings—"Bill, you *have* to tell *me*." (Listen for that artificial emphasis—the leaning on the words—that shows the individual is struggling to make the words interesting.) Ask the actor to *imagine* what will happen if he or she is successful in this quest and what will occur if he or she fails. Urge the actor to forget about feelings and line readings. Remind the actor that

action will produce emotion and the feelings experienced will provide all the emotional color the words need.

Add your favorite coaching comments here:

Watch out for the traps:

Occasionally an actor will try to avoid the work by insisting he or she doesn't understand the exercise. Some people would rather claim ignorance than experience the uneasiness that may result from internalizing a passionate and unsatisfied need. Remind the player that the discomfort is the fuel that drives the action and encourage him or her to take the emotional risk.

Some actors fear that wanting something makes them appear weak in the eyes of the viewers. The players need to understand that an audience does not think less of an actor because he or she commits to a need. Instead, the commitment enables the audience to empathize with the actor. Other actors need to be encouraged to stop monitoring the actions they take to get what they want. Viewers don't think less of an actor who reveals aspects of the personality that the actor may not like. The audience is grateful to the performer who reveals the inner self while playing action. An actor who has the courage to reveal his or her personal fears or weaknesses, blesses the audience with a validation of their human frailties.

Some actors assume that this exercise demands a screaming contest. They mistake rage, or manipulated intensity, for good acting. Such misguided actors will direct most of their attention to fabricating red hot passions. Remind them that the purpose of the

exercise is to experience the way in which commitment to a *want* motivates action and the by-product of that interaction is emotional responses. In the course of this exercise, those responses should run the emotional gamut. However, the feelings themselves should never be the actors' goal. If an actor continues to hide behind this synthetic emotional state, it is because he or she feels safe there. With patience and time you can draw this actor out and persuade the person to risk experiencing authentic emotions.

Tell me again why we played this game!

From the audience

"I am struck by how flexible the words are. One moment he teased her and even flirted with her when he said, 'I'm not going to tell you.' Yet, in another instance he used the same words to crush her. This helps me understand how I should use my preparation time. I need to spend more time identifying actions and needs and less time deciding how to say my lines."

"This was exciting to watch because I didn't know how it was going to end. For a while I thought she was going to persuade him to tell her, then she surprised me by pulling away from him. It reminded me that it's the action that keeps an audience glued to their seats."

"It was clear that they were really listening to one another. I could see them constantly affecting one another. This was very different from two actors pretending to listen when they are just trying to remember their next line."

"The tempos and rhythms were so rich and varied—it never got flat or repetitive as scenes sometimes do. I see that if I play action I don't have to work at varying line readings."

"The over-talking made it seem more like real people talking. I know sometimes I wait for my cue to give me permission to be affected by what the other person is saying. This was more life-like and much more exciting to watch."

"I'm surprised that there were so many emotional colors in the work, since I know the actors didn't have time to figure out

what they should feel on any given line. It's starting to make sense to me that emotions are a result of actions."

"They looked comfortable with their bodies and the way they used the space was interesting and completely natural."

From the actors on-stage

"I was less nervous than usual. I understand what you mean when you say that committing to a character's need can take my attention off my own doubts and fears. It reminds me that the character's needs should occupy the center of my awareness not my actor needs."

"I understand more clearly the role of choices. In the beginning, I decided I wanted him to tell me, but if he didn't I would get the information from someone else. My attention kept wandering. When I committed to needing the information *now* and made him my only source, it mobilized my energies and helped to keep me in the moment."

"I can't get over how easy it is! In the beginning, I could only hear my own words and they sounded stiff and phony. After I got more determined to change her mind, I didn't hear myself anymore—I just concentrated on her. She was driving me crazy for a while, but then she just broke my heart and I had to tell her."

"This exercise serves as a *check in* for me. It makes me aware of the moments when I'm running away—when I forget to listen to the other actor."

Sample lines of dialogue:

Note: Character A's line (the explicit statement of intention) always begins with: "I want you to."

A
I want you to let me be on your team.
B
I'm sorry, but we can't use you.

A
I want you to know everything's going to be OK.
B
It's not going to be all right.

A
I want you to tell me you still care.
B
I'm not sure I can say that.

A
I want you to share with me.
B
I don't have enough to share with you.

A
I want you to tell me what's going on.
B
I can't tell you that.

A
I want you to go with me.
B
I can't go with you.

A

I want you to help me out on this.

B

I can't save you this time.

A

I want you to tell me what I should do.

B

You have to make your own decision.

A

I want you to promise me you won't tell.

B

I can't make that promise.

A

I want you to make him/her leave me alone.

B

I can't make him/her do that.

A

I want you to get him/her out of your life.

B

I can't do that.

A
I want you to tell me I'm going to be all right.
B
I wish I could tell you that.

A
I want you to prove that I can trust you.
B
How can I prove something like that?

A
I want you to grow up and take some responsibility.
B
Stop telling me how to live my life.

A
I want you to trust me. This will work.
B
I just wish I could be sure.

A
I want you to tell me what we are going to do.
B
I don't know. We'll think of something.

A
I want you to know you are such a hero.
B
I wish I were, but I'm not.

A
I want you to admit that I wouldn't fit in there.
B
You would be just fine.

A
I want you to admit that I caught you red-handed.
B
Just let me explain.

A
I want you to forgive me for hurting you.
B
How could you do this to me?

A
I want you to decide if you are with us or not.
B
I need some more time.

A
I want you to admit you got what you deserve.
B
I'm not the only one to blame.

A
I want you to tell me you won't leave me.
B
I would stay if I could.

A
I want you to know that I did the best I could.
B
It wasn't good enough.

A
I want you to stop taking his/her side.
B
I'm trying to be fair.

A
I want you to give me a second chance.
B
I don't know if I want to try again.

The Playing Is The Thing

A
I want you to share your secret with me.
B
I'm not sure I can trust you yet.

A
I want you to stop and watch me do this.
B
I don't have the time to watch you.

A
I want you to admit that you are wrong.
B
No. I'm right about this.

A
I want you to know that you can do this.
B
I can't do it.

A
I want you to let me help you.
B
I'd rather do it myself.

A

I want you to take me seriously.

B

I don't see any reason to.

A

I want you to know you did the best you could.

B

I should have done better.

A

I want you to tell him/her for me.

B

I can't do it for you.

A

I want you to tell me what happened here.

B

I wish I knew what happened.

A

I want you to stop telling me what to do.

B

I'm just trying to help.

A

I want you to stop hurting him/her.

B

This is none of your business.

A

I want you to know this is the last chance you get.

B

Don't give me ultimatums.

A

I want you to tell me there's been some mistake.

B

No, I'm afraid there is no mistake.

A

I want you to admit you let me down.

B

I don't owe you anything.

A

I want you to help me out with this.

B

I can't even save myself.

A
I want you to admit you brought this on your self.
B
You never see my side of it.

A
I want you to ask him/her for me.
B
It will mean more coming from you.

A
I want you to stand up for yourself.
B
Let me do this my own way.

A
I want you to admit you ruined my chances.
B
It seemed like a good idea at the time.

A
I want you to tell me why you are doing this to me.
B
This isn't about you.

A
I want you to look at it from his/her point of view.
B
I'm tired of taking care of him/her.

A
I want you to tell me how you're going to make this right.
B
I understand how upsetting this is.

A
I want you to agree that everybody has let me down.
B
Try seeing someone else's point of view.

A
I want you to know he/she really loves you.
B
Then why does he/she do this to me.

A
I want you to explain why you're never there for me.
B
I'm doing the best I can.

10
Magical Machines

There are numerous popular games in this genre. Several of the variations in this chapter were created by my actors in our **Bending The Rules** sessions (Chapter 14).

These games emphasize physical interaction, and for many actors physical interaction paves the way for psychic and emotional interaction. This is a playful way to convey a better understanding of cause and effect, give and take, action and reaction.

The payoff:

- **Ensemble**
- **Getting actors out of their heads and into their bodies**
- **Interaction**
- **Relaxation**
- **Spontaneity**
- **Physical warm-up**
- **Listening**

How to play the game:

1. Let's Build A Machine

When possible all the actors should participate. However, a group of fourteen or fifteen is the optimum group size.

Movement

The actors stand in a semicircle leaving a large, open playing space. One actor steps forward and sets the machine in motion. The goal for this player is to *discover* movement, rather than to contrive a movement that is clever. Encourage the actor to *listen* to his or her body, noting any muscles that want attention. For example, there may be a little tension between the shoulder blades. "Mmm," the actor thinks, "rolling my shoulders would feel nice." From this simple action the movement grows. The actor only needs to surrender to the *ripple effect* or *domino effect*. The motion of the shoulders causes the arms to move. When the arms are swinging freely, the upper torso is affected and eventually the lower torso responds, and so on throughout the body.

The player then formalizes the movement into a repetitive pattern. For example, the player may end up pushing the fists forward straight out from the body in a type of punching moment while doing a shallow knee bend.

When you introduce this game, you will observe actors who trust themselves to move an arm, for example, feeling that is *safe*. However, the actor waving the arm may have isolated that arm from the rest of the body. When the actor relaxes and makes the entire body available, some residual effect will eventually be sensed even in the feet. If the player is relaxed, the movement eventually ripples throughout his or her body. The goal isn't to have all the players doing a *body wave*. Instead, the game encourages players to free muscles, tendons, and joints so their bodies react normally to movement.

Sound

When the entire body is participating in the movement, invite the actor to allow the movement to *push out* a sound. Any sound is perfect. Only language should be avoided.

Adding the parts

Actor #1 may be holding his or her arms out to the side and moving them up and down. (Think of a flying motion.) This person becomes the fulcrum of the machine. Without analyzing or judging this movement, another actor volunteers to step forward and add to the machine. This second actor touches a part of Actor #1's moving body. Actor #2 might, for example, grasp Actor #1's right elbow or that person's shoulder. Actor #2 only has to relax and allow the ripple effect to operate. Again, the moving hand will affect the arm, which will move the trunk, which will set the legs into motion, and so on. This player also allows the physical activity to generate a sound.

All the players should eventually join in, adding new movements and sounds that ultimately create a human *machine*. Encourage the actors to connect with body parts other than hands and elbows—only a few body parts are off limits for connecting to the machine. Ask them to see what happens if they attach at the shoulder, kneecap, back of the knee, ankle, wrist, or top of the head, for example.

2. Blind Man's Machine

The players begin the game with their eyes closed. Guide one person to the playing area and that individual discovers a movement and sound, thus setting the *machine* in motion. Lead the remaining players, one at a time, to the *machine*. Connect each individual to a moving part of the *machine*. Remind the players that keeping their eyes closed and being patient will help them discover a movement. When all the players are participating, tell them that they can open their eyes but keep the movement going.

This variation is particularly useful for freeing actors. Since the players can't evaluate the movement in progress, they avoid the temptation to prejudge their own contribution. The players are inclined to risk looking silly because no one is watching.

3. Batteries Not Included

All the players gather in the playing area and physically link up with one another. Urge them to find unusual ways to connect. Encourage them to make more than one connection so all the bodies are intertwined. When the linking is complete, ask one person to begin the movement and sound. The energy flows from that person outward, eventually involving all the players and producing a *machine*.

4. The "Morphing" Machine

Build a machine using versions 1, 2 or 3. After the machine is in motion, provide side-coaching to stimulate the actors' imaginations. Suggest, for example, that this machine has a gasoline-powered engine and all metal parts. After a couple of seconds, tell the group that this machine has been refitted with plastic parts. A few seconds later ask them to "morph" themselves into a wind-driven device or a solar-powered machine. Images describing the machine's location—a mountain-top, underwater, underground, seaside, outer space, etc.—will further stimulate the actors' imaginations and help them focus on the doing.

5. Assembly Line

The actors stand in a circle. A volunteer player creates a set of movements accompanied by sound. That player then crosses the space, continuing the rhythmic movements and sound. He or she selects, at random, a second player and *delivers* the sound and movement to that person. As the first player stands facing him or her, the second player begins to mimic Player #1's sound and movement. The two players trade places—Player #1 takes Player #2's place in the circle while Player #2 moves toward the center of the circle. Player #2 transforms the first player's sound and movement into his or her own sound and movement while moving across the circle to another player. Meanwhile, Player #1 continues the sound and movement he or she originated. Eventually all the players are producing sound and movement to produce a machine.

6. The Jigsaw Machine

The players stand apart from one another, each establishing a pattern of movement and sound. Appoint one player to become the fulcrum for the machine. Each player then finds a place to connect to either the fulcrum or one of its attached parts without impairing his or her movement and sound. Suggest thinking of this game as an animated jigsaw puzzle.

Coaching the players:

Side-coaching is critical for these games. There are so many traps, particularly in the learning stages. Your running commentary will keep the actors focused on the doing.

"If you don't know what to do, it's the perfect time to join in."

Remind the players that when they have no idea what to do, they are in the perfect state to join the game. They won't be hindered by any mental baggage. Suggest that they take advantage of the opportunity to join in while they are open to possibilities. Encourage them to connect with a moving part without knowing what will happen. Remind them that they can't possibly make any mistakes.

"If you get an idea, wait until it passes."

I frequently use this as a reminder when I see players who are studying the machine trying to come up with an appropriate response. Watch the actors as they approach the machine. Some are measuring what they see and contriving a response before they make a connection. Remind them to leave their ideas behind.

"The machine is a work in progress."

The actors need to give themselves to the process and ignore results. No movement is *right*; no movement is *wrong*—it *simply is* whatever it is.

"Surrender to the ripple effect."

The actors need to remember that they don't have to *make* the ripple effect work. They only need to *allow* it to work. If they are patient and allow themselves to be affected by the movement,

their bodies will react. Remind them that if one connects his or her hand to something that is moving, the hand will move. When the hand moves, the wrist has to move. If the wrist is allowed to move freely, the lower arm will follow. If the lower arm is allowed to move, the upper arm will be affected. If one surrenders to the ripple effect, a connection with something that is barely moving can affect one's whole body.

"Allow the movement to push a sound out of your body."

The players should let the action *push* sound out of their bodies—just as squeezing a toothpaste tube forces out the paste. The focus shouldn't be on cleverness or invention. The players should think of the sound as a product of the movement.

"Whatever sound comes out of you is perfect."

The actors should feel free to produce unedited noise. They may moan, hum, snort, chirp, wail, peep, or hiss.

"Make *big* sounds."

This is an excellent opportunity to help actors see how they protect themselves by producing timid sounds. A tight throat forms an effective wall sealing off the viscera, or gut. An open throat leaves the viscera unguarded and the actor more vulnerable. When these games get going, the group is apt to get fairly raucous, but in the beginning they may need permission to free their voices.

Add your favorite coaching comments here:

Watch out for the traps:

Some actors will be paralyzed by these games. They will hang back waiting for the *right* time to join in—hoping to fabricate a response *before* connecting to the stimulus. These are frequently the same actors who never really listen during scene work—the ones who are always a half step ahead—thinking about their next line while the other character speaks. If you have an actor who is *stuck*, have that person close his or her eyes and use the rules for **Blind Man's Machine**. If you have several players who are *in their heads*, alternate between **Let's Build A Machine** and **Batteries Not Included**.

Watch for the actors who are holding back and making only the most tentative sort of connections. They are being careful to come up with *good* additions to the machines. Remind them that there are no standards for good or bad movements.

The need for physical contact will stop a few of your players in their tracks. These individuals will need considerable encouragement to touch another player before starting a movement. These are usually the same actors who, when playing a scene, can rarely be persuaded to invade another actor's personal space. Stiffening their bodies to ward off all stimuli, these actors exist in a constant *shut down* or closed state. These games provide actors a *low risk* opportunity to become accustomed to physical interaction. When the physical barriers begin to fall, psychic and emotional interaction often follow.

Tell me again why we played this game!

"It's all about trust, isn't it? When I trusted that getting involved would produce a result, I was free of the pressure to come up with solutions. That's when I could listen and see what was going on."

"I'm beginning to recognize that the time I spend censoring myself really is a waste of time. What I need to do is just get on with it."

"It reminded me that when I concentrate on doing, on the task, I automatically relax. I noticed that if I just paid attention to what was already happening, rather than attending to my fears, my self-awareness melted away."

"The first time we played **Blind Man's Machine** I felt panicky. I couldn't imagine how I could join in if I couldn't study the movements in progress and think up an appropriate addition. It was such a revelation to me that I could relax and just depend on my body to respond. I feel so much freer now. I realize that it doesn't make sense to torment myself trying to predetermine reactions."

"These games are helping me get over the fear of invading the other person's personal space. At first, I was totally intimidated by the prospect of *having* to make physical contact and would do almost anything to avoid it."

"I'm getting over the need to be 'right' or 'interesting.' I'm beginning to allow myself to have fun! I can't wait to have that same freedom in my scene work."

11
Group Juggling

A student of mine, Doug Goetz, taught me this game. He adapted it from a game he learned at Michigan State University. It provides an exceptional opportunity for developing concentration and listening skills, and helps actors understand what is meant by "making a connection with a fellow actor." It's a lively method for teaching actors the value of teamwork. You will also find it useful as a warm-up before a rehearsal or a session with advanced actors. It will loosen up the group, get their minds off any anxieties, and point them to the specifics of their job.

The payoff:

- Concentration
- Listening
- Ensemble
- Interaction
- Relaxation

How to play the game:

The "prop" list

The players will need something to juggle. I like to work with pieces of paper wadded up to resemble small balls. You might work with actual balls, but make sure they are very soft and large enough to be seen easily.

The ground rules

A group as large as fourteen or fifteen can play. The actors should stand forming a circle with comfortable elbow room. Each participant needs to know the names of all the other players.

Start the game with one ball. The game begins as follows:
Jane:
- calls Tom's name
- makes eye contact with Tom
- tosses the ball to Tom

Tom:
- calls Sue's name
- makes eye contact with Sue
- tosses the ball to Sue

Continue this action for a few beats until the participants are clear on the three steps: calling the player's name, making eye contact, tossing the ball. Then introduce a second ball and, if all goes smoothly, toss in a third and so on until the group is juggling as many balls as they can physically manage.

Don't be discouraged if the group can't keep more than a couple of balls going in the beginning. This is an exacting test of concentration, discipline, and listening skills. With a little practice and patience the group will be juggling a number of balls and having fun in the process.

Coaching the players:

The side-coaching is crucial for this game. Particularly during the first few times they play, the group is almost certain to face numerous failures. They will need suggestions such as these to keep them pointed toward the doing:

"One step at a time."

The success of this game hinges on the players' willingness to work slowly in the beginning. If there are more balls on the floor than in the air, stop the game and review the three steps: call the player's name, make eye contact, toss the ball. Remind the players to proceed patiently through the three steps, one at a time. "Slow and steady wins the race."

"Make eye contact."

The step most often slighted is eye contact. The players should never assume they have another person's full attention just because they have called that person's name. After Tom calls out Jane's name, he must wait until he and Jane make unmistakable eye contact, then throw the ball to her.

"Keep your eye on the ball."

The eye contact must be regarded as a solemn contract. For example, if Tom calls Jane's name and Jane makes eye contact with him, she has pledged to keep her eye on the ball Tom throws to her. She has promised that she will not be distracted if a third party calls her name.

"Be a team player."

Remind the players that the objective is to keep as many balls in motion as possible and that requires a group effort. This is an excellent game for promoting that synergy that is essential for any group mounting a production.

Add your favorite coaching comments here:

Watch out for the traps:

Try outlawing overhand throws to prevent the aggressive types from making tosses that are especially difficult to catch.

You may run across some players who think it is more fun to fake out fellow players than to help the group keep several balls in the air. To cope with this try fining the thrower whose toss is missed. It's amazing how quickly the jokers will get serious about making eye contact before they throw the ball!

The players who aren't good at sports may be intimidated by this game. Remind them that this isn't a tryout for major league ball. No one will be judging their eye-hand coordination. Urge them to take their time and focus on establishing eye contact and listening.

Tell me again why we played this game!

"This game reminds me to avoid rushing. I caught myself throwing the ball before I had made eye contact. Sometimes during a scene, I panic and rush ahead thinking of my next line instead of listening to the other actors. I rush because I am afraid of falling behind, afraid of failing. It's interesting that the fear of failure is what brings about the failure."

"Each time I missed the ball, it was because I lost my concentration. I was distracted by all the balls flying and took my eye off the one coming at me. It calls to mind the occasions when I

drop character or forget my lines because I am distracted by what I think the audience may be thinking. I am beginning to understand that most of my acting problems boil down to concentration problems."

"At first I got a bigger kick out of catching people not looking and making them look silly because they missed the ball. But when we got going, it was even more fun to be part of the group effort. I never dreamed we could keep that many balls in the air— it taught me what teamwork can accomplish."

"This workout took my mind off the scene work ahead of me. I was tense and all caught up in my fears about lines and new props and business, but this reminded me to take everything one step at a time and not rush."

"Over and over I have to learn the lesson about staying in the moment. I missed the ball several times because I was thinking about who I would throw it to after I caught it. One of these days I am going to learn that 'staying in the moment' isn't just a catch phrase—it really is the secret to successful execution."

"I always find it relaxing to play a game that keeps me focused on the doing and off my self-doubts. It reminds me that I must carry that same mentality into my acting."

"This game reminds me how complicated and difficult a task can be when you ignore specifics and hurry through the generalities. On the other hand, that same job is relatively simple when you know where to place your concentration and are able to screen out the distractions."

"Once I got over my impatience to throw the ball, I discovered that the eye contact was very helpful. I could feel that solid connection between me and the other player. The connection was like an invisible wire linking us and it was as if I could send the ball along that wire."

"When we first got several balls in the air, all I could hear was this jumble of noises. It wasn't easy to filter out the distractions and listen just for my name among all the other names being called. In the beginning, I was also distracted by how well or how badly other people were playing. It felt great to zero in on my target and use my concentration skills."

The Playing Is The Thing

"This game is just plain fun! It's a great lesson for me that fun is a by-product of strict concentration and teamwork."

"The toughest tests for my concentration came when I had already made eye contact with one player, the ball was on the way, then another player called my name. At first, I couldn't resist the temptation to turn my attention toward the second person calling my name. I would take my eye off the ball for that split second and boom!—it was on the floor. In spite of those foul-ups, I know my concentration is improving and I can see the difference it is making in my scene work."

12
Tell Me A Story

I find group story-telling games extremely useful as warm-ups. While they present many more pitfalls than the games in **Playing Catch** (Chapter 6) or even **Magical Machines** (Chapter 10), they are excellent for honing basic skills.

Theatre games that involve group story-telling have become staples of improvisational groups. I offer some of my favorite versions, several of which were created when my actors played **Bending The Rules** (Chapter 14).

The payoff:

- **Listening**
- **Ensemble**
- **Spontaneity**
- **Concentration**
- **Imagination**

How to play the game:

As many as a dozen or so players can participate in these games. The players stand in a semicircle facing the leader. The group tells a story with each player taking turns contributing to the narrative.

I tell actors to imagine that we have a *special machine* that records the story. It homogenizes the voices, so that the listener, hearing the play-back, will think a single person told the tale.

1. Line-By-Line Story

(Viola Spolin calls this game "Story-Building.")

The first player starts a story. After a sentence or two, signal the next player to pick up the narrative. Allow each player to contribute a phrase or two, before signaling the next player to continue the story. Give each player two or three opportunities to participate (depending on the number of players) then signal one of the players to conclude the story.

Hand signals

Demonstrate and identify two hand signals:

- a gesture that signals the *passing of the baton.*

 I simply point to the next person in the semicircle to indicate that that person should pick up the story.

- a hand motion to signal: *Wrap it up.*

 I use a circular motion to indicate that the next player should end the story.

Example

(The / denotes that the next player in the semicircle is signaled to pick up the narrative.) The story might sound like this:

Player #1

Once upon a time there was a little red-haired boy named Sam. Sam was only six and he /

Player #2

had no brothers or sisters. But Sam had a best friend. His best friend /

Player #3

was a scruffy old Lab named Pokey. One day Sam decided /

Player #4

he wanted some ice cream. He knew he wasn't supposed to leave the yard alone, but /

Player #5
**he said, "I'm not alone. Pokey is with me." So
Sam opened the gate all by himself and said, /**

Player #6
**"Okay, Pokey let's go get some ice cream. So
Pokey /**

2. One Word Story

Once the players have a feel for the game, advance to classic
One Word Story. In this version of group storytelling, each
player contributes only one word. The story moves around the
circle or down the line.

Here is an example:

Player #1
Once
Player #2
upon
Player #3
a
Player #4
time
Player #5
there
Player #6
was
Player #7
a

If someone accidentally says two words, don't stop the game.
Let the players know that it may take several tries before a story
takes off. When one story breaks down, don't allow anyone to
dwell on self-criticism. Remind the actors that each time the story
falls apart everyone in the group learns more about storytelling.
Be sure they simply dive into the next story.

3. Pass The Story Please

In this variation the players establish eye contact, then physical contact when passing the story. The players stand in a circle. Player #1 imagines holding the story in his or her hands. That person turns to the person next to him or her, makes eye contact, and, while speaking the word, *places* "once" in Player #2's hands. Player #2 turns and *hands* "upon" to Player #3.

If the group is having problems with concentration, this version is a great place to start.

4. One Word Story—On The Time Clock

In this game, you instruct the participants to complete the story in three or four rounds of the circle, depending on the number in the group. This version will impress upon the players the value of simplicity. The players soon learn that too many characters and not enough action make it impossible to meet the deadline.

5. Toss The Story

The players stand in a circle. The first player makes eye contact with another player in the circle then *tosses* "once" across the space to that player. The second player makes eye contact with another person and *throws* "upon" to the next player.

6. Verbal Ping-Pong

Divide the group into pairs. (If you are working with an odd number, have three people work together.) Each pair tells a story one word at a time producing a kind of verbal Ping-Pong. All the players work at the same time.

It will help to:
- Separate close friends.
- Be sure the players don't take time to do a story conference in advance, or stop to work out story problems.
- Encourage people to work quickly.

The room will get fairly noisy, but the racket provides an ideal opportunity for sharpening concentration skills.

Coaching the players:

The first few times the actors play this game, they are apt to stumble frequently. Encourage them to develop a sense of humor about their thwarted efforts and to simply begin again. It's best to abandon a broken story, rather than try to fix it. When a story breaks down, point out why the story fell apart before starting the next story.

"Let the story tell you."

The player who is *actively* listening creates mental pictures that bring the story to life. Conversely, the player who thinks ahead, deciding where the story should go, is too preoccupied to create mental images. The preoccupied player will miss *the passing of the baton.* The actors soon learn that, when the time comes for them to make their contribution, it is too late to make up for not listening. I tell my actors to let the story tell them.

"Trust your impulses."

There is no time for the players to censor their contributions. Each participant must trust that his or her addition will move the story forward.

"Keep the story simple."

Prompt the actors to tell a simple story—one they might tell to a child. This will help them remember to limit the number of characters and be mindful of action.

"Concentrate on action."

Verbs move the story forward.

"Supply obstacles."

Obstacles supply the drama in the story. In some groups, you may find actors who have a tendency to overwhelm the story with obstacles. You may need to coach in the opposite direction.

"Name all the characters."

Pronouns without clear antecedents create confusion that will cause a story to bog down.

"Don't be afraid of periods."

It will be much easier to tell the story effectively if the players limit themselves to short sentences. This means they have to

acknowledge periods and avoid tacking on an endless series of conjunctions. When one player indicates, through inflectional pattern, the ending of the sentence, the next player must acknowledge the period and be courageous enough to begin a new thought.

"Supply vivid images."
Vivid images will stimulate the other players' imaginations.

"Keep the story moving."
It doesn't help to go slowly and cautiously. In fact, slowing the pace too much will cause the story to bog down.

"Reweave themes and images."
The storytellers can insure sound story structure by repeating themes and images that tie the story elements together.

"Don't double back."
The players should not stall by doubling back and repeating the word, or phrase, they just heard.

"Say yes."
The players must use what they are given. Each player must be willing to tell *this* story, rather than try to wrest control and twist the story to suit his or her personal taste.

Add your favorite coaching comments here:

Watch out for the traps:

While these games have many parallels to the **Playing Catch** games in Chapter 6, they add new complications. There will be false starts and stories that become hopelessly mired. Keep the

players focused on the doing. Some of them will find plenty of reasons to beat up on themselves. It may take longer for them to acquire the skills needed to tell coherent and effective stories than to play **Sound-Ball** (Chapter 6), but the payoff is worth the effort.

Some players may be petrified by the prospect of creating a story. Remind the group that the goal isn't submitting a story for publication. The purpose of the storytelling is to hone skills the players will use on-stage. Urge them to practice listening, saying "yes," and letting the story tell them.

Some people delight in derailing the story. They inject a character who does not belong, action that contradicts previous action, or action that drastically alters the tone of the story. Remind the players that anyone can wreck the story. The challenge is to keep the narrative on track.

Tell me again why we played this game!

"These games helped me see how weak my concentration skills were in the beginning. Now when we do the two-person version, I'm not distracted by the other stories going on around me."

"I'm beginning to understand the difference between involved, or active, listening and just hearing. If I'm not actively listening— if I'm not already participating in the story before my turn to speak, I will kill the story."

"These games provide another lesson in trust for me. The first time we played I was a basket case. I was sure that I wouldn't come up with anything to say when my turn came. So I would try to get a head start by thinking of something two or three people ahead. Then, since what I had planned ahead obviously didn't make sense by the time the story got to me, I would panic. Nothing would come out of my mouth. Now I trust that what the person ahead of me says will activate my brain and something will sort of pop out of me."

"When we started playing this game, I got distracted by my need to show off my cleverness. I would stop concentrating on the story being told and think up cute or funny things I could say

when the story got to me. I finally learned that there isn't a place for showing off in this game. It has to be a group effort."

"I loved that sense of being part of a whole, part of something larger than myself. It's liberating to be part of something flowing like that—to know that I'm just one of the pieces."

"I still get nervous when we begin any of these storytelling games. However, I'm learning to concentrate on listening. That relaxes me."

"These games have taught me that slowing the pace doesn't help me concentrate. It's really the reverse. The more I slow the pace—the more I watch myself, and the more I watch myself—the more I lose my concentration. And, of course, when I lose my concentration I always mess up."

13
Can You Top This?

This game is useful for helping actors understand how to *top* another player and build a scene. The actors learn that topping isn't an arbitrary and theatrical behavior, but the kind of real-life listening and responding everyone does. In real life, we all play this game on a daily basis. "You think you were sick? I had the worst flu I've ever had. I was flat on my back for three solid days." Or "I know exactly what you mean. That reminds me of the time we were on vacation and"

This game is also excellent for developing listening skills. The actors soon learn that it is only possible to outdo a story if they have *heard* it. Only by listening carefully to specifics can they expand on the other player's story. The actors will have fun playing this game and as audience members they will find it one of the most entertaining of the workouts.

The payoff:

- **Listening**
- **Interaction**
- **Spontaneity**
- **Imagination**
- **Concentration**

How to play the game:

The actors work in pairs, one pair at a time, in front of the group. The players do not take time for a conference before the game begins.

Top the other person's story

The object is for the players to alternate telling brief stories each of which outdoes, or *tops*, the preceding anecdote. One player begins by describing an experience. After listening to his or her partner's story, the other actor responds with something along the lines of: "Wow, your experience is impressive! And that reminds me of a similar, but even more astounding, experience I had"

For example, Bob might tell Jane that he did some fancy Rollerblading at the local park and was applauded by a group of onlookers. Jane should acknowledge Bob's story then top it. For instance: "Oh, that's great that the crowd applauded your skating—that reminds me of the year I went to the Olympics as an ice skater. The crowd loved my triples." Next Bob tops Jane's story with one of even more heroic proportions.

The players may also outdo each other by proving that their experiences have been more painful than their partner's. For example, Mike begins by sharing that he is exhausted by having worked all day in a soup kitchen helping the homeless. Debbie counters by saying how much she admires Mike for helping the homeless and wishes she could join him at the soup kitchen. However, she regrets that taking care of her seven adopted children and two aged parents keeps her at home all day. Now Mike has to make his work at the soup kitchen even more exhausting and charitable to top Debbie's story.

Watch that first step

The most difficult moments in the game are the first couple of exchanges. Once the players establish the theme, they create a momentum that propels the action forward. When the first player tells his or her story, there are two or three themes that could be

picked up by the listener. For example, in Bob's story about Rollerblading there are a couple of possible themes. Jane could pick up on the idea of winning personal approval and ignore the skating theme. She could focus on the fact that this was an event that occurred at the local park and talk about her exploits that took place there. Once the theme is established, the players should follow it through.

The sky's the limit

Be sure the players know that they are not bound by literal reality. Encourage them to use their imaginations to go one better. The game that began with a simple story of Rollerblading at a local park might evolve into something at first beyond anyone's wildest dreams. Bob might eventually top Jane with: "That's great. I'm really happy that you won all the medals at the Olympics that year. What a thrill that must have been. That reminds me that I have to call my agent because he wants to set up my appointment with the International Olympic Committee. You know they are scheduling a special celebration in my honor next year. I have been declared ineligible in all athletic events, of course, since I have now won medals in every competition. They have scheduled a worldwide affair where the athletes from all over the world come to study my training techniques."

Stepping stones

Help the actors see that the goal is to *build* to a climax. Each actor's objective is to outdo his or her partner's stories by building on each anecdote, detail by detail, rather than attempting to go for the top immediately.

Details, details, details

Urge the players to focus on details. Notice that in the second example given, Debbie tops Mike's story by telling him about her seven adopted children and aged parents. She doesn't counter with a vague comment about a number of people who are in her care. She makes the story more real for both herself and Mike with these specifics and the details provide a clear target for Mike. He now knows precisely what accomplishments he must surpass.

Have fun

Everyone will have fun with this game. Encourage the players to relish the sport of outdoing the other person's story. The group will enjoy seeing who can be more pitiful, brave, agile, alert, lucky, unlucky, and so on.

Coaching the players:

You probably will rely mostly on pre-game and time-out coaching after the actors learn this game. However, the first few times the actors play you may have to side-coach with suggestions such as these:

"Listen to his/her story."

The players must hear the pertinent details of each of their partner's stories. Those details are what must be expanded upon. The player who misses the specifics of a story has no *ammunition* for surpassing it.

"Say yes."

The actors should build on the other person's story rather than disputing it. They need to understand that denying the validity of the other player's story stops the action in its tracks.

"Draw from your own experience."

Remind the actors to draw on personal experience. If an actor is stuck, at the beginning of the game, even the most mundane experience will set the game in motion. Using their adventures as a stimulus for their stories will also put the actors in a position to take advantage of a wealth of specific details.

"Be specific."

The details are what spur the imagination and trigger new possibilities. Generalities piled upon one another create a bog that will eventually stop the action.

"Stay with the story."

The players need to know they should stay with a theme and concentrate on expanding on it with each story. Often there is a temptation to panic and switch themes in a desperate attempt to top the other person.

Add your favorite coaching comments here:

Watch out for the traps:

Watch for the players who will try to keep the upper hand by disputing the other person's stories. For example, when Bob tells Jane that he did some Rollerblading at the local park last Saturday and was applauded, Jane may attempt to disprove the story. She might reply, for example: "Oh, I was there and they weren't really applauding you." Or, "Why you couldn't have been at the park. I was there and I didn't see you." Denial will stop the action. Urge the actors to contribute to the action rather than blocking it.

If actors are allowed to indulge in cutting one another down, rather than topping, the game will degenerate into a mere *put down* contest. For example, when Bob tells Jane the Rollerblading story, Jane might attempt to belittle him instead of topping his story. The response might be: "Well, I'm not surprised the crowd applauded you. You know it doesn't take much to please the crowd at the park. I, on the other hand, was applauded by experts in the sport." Encourage the players to acknowledge the other person's story, then outdo it.

Sometimes actors will settle for outdoing one another with tales about acquiring larger and larger sums of money. Undoubtedly this tactic does qualify as one-upmanship. However, the recitation of escalating sums of money—no matter how specific the amounts may be—eventually loses everyone's interest. Encourage them to tell us the interesting stories of how they acquired the money rather than settling for larger and larger numbers.

Tell me again why we played this game!

"When I first began to play I got panicky and tried to plan ahead so I would have some good *ammunition;* then, of course, I realized that was senseless. I had to listen to know what I was trying to outdo. Now I feel foolish recognizing how often during a scene I think about my lines when I should be listening."

"I loved the way people used their bodies to communicate their stories and the way their bodies reflected their listening. If we all were that physically involved while acting, our scene work would be much more exciting."

"This game gave me a new appreciation for the value of specifics. You could easily tell that when the players were committed to their objective, they packed their stories with descriptive details. During those periods, my attention never wandered. On the other hand, when the stories became general it seemed to be brought on by the players' lack of attention and I lost interest."

"It fascinates me that I had such a strong connection with the other player, yet that was never my primary concern. I never *tried* to establish a link. The connection just naturally grew out of my commitment to my objective. Listening was the *only* way to discover what I would have to outdo. I also *had* to be keenly aware of my fellow player's response to my story. The other person's reaction was what signaled me whether I had succeeded in topping him or her."

"It's interesting to me how the work is so animated and none of the energy is super-imposed—it is totally organic."

14
Bending The Rules

This warm-up gives the actors responsibility for creating new games based on games they know. It promotes a playful and creative state of mind and is an excellent way to develop ensemble.

This workout will help your actors make friends with uncertainty. They will develop a tolerance for the apprehension they feel when you ask for more spontaneity in performances. The actors are asked to conjure up games, then throw themselves into the playing before anyone knows whether or not the games will *work*. Actors who have coped with this anxiety are less inclined to be intimidated when asked to relinquish rehearsed line readings and planned emotional responses. As one of my actors said, "By comparison, improvising within the confines of a scene is *a piece of cake*." **Bending The Rules** will provide your group with one of their most energizing and creative workouts.

The payoff:

- **Ensemble**
- **Spontaneity**
- **Imagination**
- **Getting actors out of their heads and into their bodies**
- **Freeing the body**

- **Interaction**
- **Concentration**
- **Physical warm-up**
- **Vocal warm-up**

How to play the game:

The group warms up with a game such as **Sound-Ball** (Chapter 6). After the warm-up, review the basic elements of the game then let the actors brainstorm to create new games based on that prototype. (The games from **Playing Catch** (Chapter 6) and **Magical Machines** (Chapter 10) make especially effective models.) Urge the actors to offer the group any notion that comes to mind, regardless of how silly it seems. Encourage them to volunteer even the most vague possibilities—thoughts that haven't fully formulated in their minds. This is a group effort. The players must trust the group to embrace each idea and explore it. Be sure the actors understand that there are no *failures* in this experiment. Urge them to enjoy strengthening what Roger Von Oech, author of *A Whack On The Side Of The Head*, calls the 'risk muscle.'

The ground rules

The actors focus first on the specific elements of the model game. For example, the elements of **Sound-Ball**, are:

- standing in a circle
- throwing an imaginary ball
- receiving and sending a sound
- repetition followed by transformation

Next the players should imagine converting the game by:

- altering existing elements
- adding new elements
- expanding on existing elements

For example, **Sound-Tag** (Chapter 6) is a game that came out of a rule-bending session in one of my classes. The players continued to send and receive sound, but altered one element and

added another. In this new game the players don't throw the sound, they hand-deliver it and the sound becomes a continuing one. The new element is the requirement that all players, except the one who is *it,* play with their eyes closed.

Three Part Sound-Ball (Chapter 6) is another game created by my actors. We focused on the requirement of creating a sound to travel with the ball, then expanded on that element. The result was a type of **Sound-Ball** that requires a sound of no less than three parts, or *syllables.*

The leader steps out of the spotlight

The leader or teacher needs to recede into the background as much as possible. For example:

1. When a player suggests a variation ask that person to teach this new version of the game to the group.

2. Try naming each new exercise after the person who makes the suggestion. For instance, you might coach: "Let's play the Chris game now."

Some of the inventions will succeed gloriously during this activity, but would not translate well if formalized into a new game. Some are born out of the creative spirit and camaraderie of this particular group and wouldn't translate to another group. Neither of these facts diminishes the value of the experience. The focus must not be on creating new games to keep. The creative process is the end goal, not the games that result.

When the group has exhausted the possibilities for variations on the first model game—at least *today's* possibilities, play another game. **Let's Build A Machine** (Chapter 10) is a good choice. Urge the players to focus on changing, adding or expanding elements of this game. Turn the actors loose, then relish the delight and creativity that emerge from the chaos.

Coaching the players:

Use pre-game coaching and time-out coaching as well as side-coaching. Following are some suggestions:

"Remember the basic elements of our model game."

Stimulate the players' imaginations by calling to mind the principles of the model game. For instance, the prototype referred to in this chapter is **Sound-Ball**. Coach the actors to think about the elements of that game: standing in a circle, throwing an imaginary ball, giving and receiving of sound and energy, and repetition followed by transformation.

"Offer your idea. We promise to say 'yes'."

The players should share all their ideas with the group—no matter how silly or incomplete they may seem. Encourage the group to say "yes" to every idea offered—even when they are uncertain how they will make the idea playable. Keep the focus on expanding on or adding to an idea until the players find a way to use it. Often the suggestions that sound the most far-fetched or the most impracticable prove to be favorites.

"Offer your idea—don't analyze it."

Urge the actors to submit the idea without stopping to determine its validity or worth.

"Enjoy taking risks."

Encourage the players to laugh at themselves and the whole process. The wilder the ideas they explore, the sillier they get and the more fun they have.

"Focus on the doing—not the result."

The focus is on creating a playful energy and a spirit of exploration. This is not a game-making test.

Add your favorite coaching comments here:

Watch out for the traps:

Some of the actors will be stuck in the beginning because they believe they must come up with a full-blown game that instantly *works*. Even the germ of an idea may start the group on what proves to be a glorious journey.

Everyone will be tempted to look for *good* ideas. Don't reject any suggestions. This will inject the specter of failure which is certain to stop the flow of creativity.

The group may get off to a slow start. Give them an opportunity to warm up to the possibilities. You may need to throw in an idea now and then to *prime the pump.*

Some actors will hang back and wait for others to take the lead. Give them time. Keep the suggestions on a volunteer basis. If some people have no recommendation during the first round, wait until you have played the second game and are looking for variations. Notice something one of those players is doing and give him or her credit for an idea. Ask that person to teach the group how to play this variation.

Fear is contagious. Quickly sidetrack the "Yeah-but-what-if-that-causes-us-to" type with comments such as: "Let's try it anyway. We'll see what happens."

When a game doesn't work as well as previous ones, find something in the experience to praise. The more successful you are in convincing the group that every suggestion is a winner, the more suggestions you will get.

Tell me again why we played this game!

"This game helped me so much to get over feeling foolish and weird. We were all being so silly—doing such ridiculous stuff—it just didn't make sense anymore to worry about making a fool of myself. I know that same fear of looking foolish is what keeps me from being spontaneous in my scene work. "

"At first, I didn't trust my ideas. Then I noticed that suggestions that sounded silly at first often ended up leading us to games

that were great fun and filled with creative energy. The fact that those seemingly foolish ideas were so successful gave me courage to suggest games. I have a lot more confidence now in my creativity."

"I am surprised at how relaxed I am—how free and open I am. At first the challenge of inventing new games paralyzed me. Then I discovered how much fun it is to try all our wacky ideas. In spite of that intense physical work out, I have more energy now than I did when I came to class."

"There was such a wonderful spirit of camaraderie. This experience taught me the meaning of that saying: 'A whole that is greater than the sum of its parts.' Because I was part of this greater whole, I felt safe and free to invent and take risks."

"Because we were inventing new games, I didn't have time to develop expectations. And because we were making up the rules as we went along, I didn't have time to worry about whether or not I could follow them. Without my usual anxieties I was much more involved and creative. This was a great lesson for me. I'm looking forward to carrying that same fearlessness into all the other games and into my scene work."

15
Sing-Along

Don't let this title scare you off. You do **not** need to be a singer or musician to effectively lead this game. It is particularly effective for breaking through self-awareness, in spite of the resistance you may get from the actors in the beginning.

Try warming the actors up first with some games that encourage them to enjoy looking foolish. Games like **Sound Tag** (Chapter 6) and **Batteries Not Included** (Chapter 10) work well. A brief session of **Bending The Rules** (Chapter 14) should prime the most reluctant group.

The payoff:

- **Spontaneity**
- **Vocal warm-up**
- **Interaction**
- **Listening**
- **Physical warm-up**
- **Getting actors out of their heads and into their bodies**
- **Ensemble**
- **Concentration**

How to play the game:

All the actors should participate in this game. However, if the group includes more than fourteen or fifteen people, you might want to divide them into two groups.

The actors stand, forming a circle with comfortable elbow room. While the players will sing during this game, this is not about singing well. Let them know the areas of focus from "The Payoff," and stress that singers will not have any real advantage over non-singers.

Using suggestions from the players, choose a simple song that many of them know and the others can easily learn. We frequently use "I've Been Working On The Railroad," "My Bonnie Lies Over The Ocean," or "She'll Be Coming Around The Mountain."

Ask for a volunteer song leader to lead the group in several choruses of your selection to give everyone an opportunity to learn the words. This will also serve as a warm-up. Urge the players to sing full voice and assure them that the goal is to participate enthusiastically, not to sing beautifully. The purpose of this game is to help the players loosen up and build a tolerance for looking foolish. Sing with them to encourage them. When the group is singing full voice, stop them—let them know that they are doing splendidly—and explain some side-coaching you will be giving them.

Hand signals

Demonstrate the hand signals you will use to cue the players to slow or speed the tempo and to increase or decrease the volume. I stretch imaginary taffy to signal the singers to slow the tempo or stretch out the sounds. Moving one hand in a circular motion cues them to speed it up. I extend my arms in front of me, palms *upward*, and lift my arms to indicate more volume. To ask for less volume, I extend my arms, palms *downward* and lower my arms. Ask the group to sing a couple more choruses and experiment with your *conducting*.

Styles

After the players sing a chorus or two cued by your hand signals, call out a style in which the group is to perform. For example, you might use: *lullaby, country/western, or grand opera.* The group switches, on cue, to the form you have named. First, concentrate on musical genres. Then eventually, introduce writing styles as well. For example, you might try *soap opera, sit-com, murder mystery, Greek tragedy,* and so on. The players will learn that they must commit not only their voices but their bodies to the styles. They will strut, or slouch, or sway according to the genre to which they have committed.

Lead singers

When the players are having a good time and successfully taking style cues, introduce the next level of play. The group sings one chorus, or round, of the song. At the beginning of the next chorus, a volunteer assumes the role of *lead singer.* This volunteer signals the group that he or she will lead by moving to the center of the circle and adopting a new style. The group continues to sing, adopting the lead singer's style for that chorus. Each player takes his or her turn as leader. Be sure the actors have time to get comfortable and start having fun singing as a part of the group before you ask for volunteers to lead.

Encourage the group to improvise freely in their role as back-up to the lead singer. They may sing along or harmonize with the lead singer. They might contribute back-up effects such as humming, clapping, stomping, mimicking musical instruments, or throwing in "doo-dah's." Encourage their imaginations and full participation.

Coaching the players:

You may do quite a bit of side-coaching during this game. The first few times the group plays you are likely to encounter major reluctance. Many actors may be painfully shy about singing. Keep them pointed toward the doing.

"This is a game, not a tryout for the choir."

or

"If we aren't laughing at ourselves, we are doing something wrong."

The players need to know that no one expects them to be trained singers. Encourage them to surrender to the doing and laugh off sour notes. The point of the game is to get over the fear of looking foolish and to have fun in the process.

"Become part of the song."

Encourage the players to lose themselves in the song. Give them permission to close their eyes, if they need to simulate a singing-in-the-shower mentality for a few early rounds.

"Use your full voice."

You may want to incorporate into your hand signals a reminder to open throats and breathe deeply.

"Enjoy the plunge."

Tell the players to think of volunteering to lead the group as though it were mental bungee jumping or skydiving. This is an opportunity to make friends with fear. Assure those with cold feet that, if their minds seem to be blank, they should take advantage of this golden opportunity. Because they have no plan to execute, they are free to take the plunge unhampered by mental baggage.

Add your favorite coaching comments here:

Watch out for the traps:

The big trap in this game is that actors think the quality of their singing is what matters. Of all the games I have recommended, this is the one that is most apt to paralyze the actors. You will need to constantly encourage them to enjoy participating and help them conquer their performance anxieties.

Tell me again why we played this game!

"This exercise has taught me that I have to take risks. Invariably, my most significant breakthroughs occur when I am willing to risk looking foolish. Besides, I have learned that if I play it safe, I risk looking really foolish because I'm not participating."

"I finally got over my embarrassment about being a lousy singer and started to have fun. The fact that we were all in it together gave me permission to belt it out—sour notes and all. Really letting go like that makes me conscious of how stingy I am with my voice when I'm acting."

"I'm beginning to recognize that I need to get over this fear of making a fool of myself. I always think I will die of embarrassment, but, of course, I don't. I guess it's time I acknowledge that all that energy I spend on my fears is a waste of time."

"I surprised myself. I had never done any singing and I was amazed that I got out there and did that grand opera style. My body had never done some of those things before."

"It reminded me that when I concentrate on something outside myself, I automatically relax. Because I got lost in the singing and stopped obsessing on my fear, my self-awareness gradually disappeared."

"I have to get over judging myself, don't I? I always think it will help, but it never does."

The Playing Is The Thing

"I especially liked the parts where we had lead singers and we were all working together. It was pretty amazing the way we picked up cues from each other when we had never practiced before. I know that's because we were really listening to one another."

16
In Your Own Words

This exercise will help actors learn to *get the thoughts before the words*. I always remind my actors of the old maxim: "Don't put the cart before the horse." The cart is not capable of pulling the horse. The horse is the power source. The horse, therefore, *must* be out front if the cart is expected to travel.

It's painful to watch an actor struggle vainly to bring life and spontaneity to the work only to find the words becoming more wooden with each attempt. The exasperated actor tries to force-feed life and meaning into the words and ends up feeling stuck. This is an actor who doesn't understand that thoughts power words. The actor who taps into the character's mental process discovers that one can trust the thoughts to summon the words. Use this exercise to get that horse out front where he belongs!

The payoff:

Spontaneity

Scene analysis

Learning lines

Imagination

Understanding character needs

How to play the game:

Each actor should bring in a short monologue. Limiting the monologues to a minute will allow time for all the actors to complete the exercise.

Outside preparation

Give the players notice of this exercise to allow time for selecting and preparing a piece. The actors should not memorize their monologues for this first version of the exercise. The actors should explore the material and make strong, personal choices; however, they should not *practice* their monologues. The actor who almost immediately locks into line reading patterns may even need to avoid reading the monologue aloud. (The exercises from Part III will help the actors analyze the text.)

I have had actors who come to the session without a prepared piece do what we call a *deep-freeze reading*. This is a reading that is colder even than a cold reading—*no* time for preparation. These actors can still benefit from the exercise. Obviously, the workout will be of much greater value if the actors have done their preparation.

The actors work one at a time in front of the group.

Exploring the material in front of the group

Step 1: the first reading

The actor reads the monologue in front of the group.

Step 2: the improvisation

The actor improvises the piece focusing on the thoughts the character wishes to express. The actor should concentrate on: the main events of the story, or the primary arguments in the character's case, or the principal offers the character makes in the negotiation process. Urge the actor to put the thoughts into his or her own words. When an actor *does* happen to remember the text, that's fine. The actors shouldn't police themselves to avoid lines from the script. However, be certain that everyone understands this is *not* a test to see who can learn lines quickly.

Step 3: second reading

After the improvisation, the actor returns to the script and reads the monologue aloud again. The actor should *not* improvise any words during this reading. This reading should be faithful to the text.

Step 4: second improvisation

After the reading, the actor improvises the speech again. More of the writer's words will naturally find their way into the improvisation. While this is a natural by-product of the exercise, it should not become the focus of the work. The actor should once again concentrate on the character's needs and actions.

(Needs and actions are explored in **I Want You To,** Chapter 9; **Treasure Hunt,** Chapter 19; and **Eight Line Scenes,** Chapter 20.)

Step 5: third reading

During the third reading of the material, the actor begins to hook more securely into the ideas behind the words. More energy is spent wrestling with thought process than manipulating line readings. This will allow some of the improvisational inner life from Steps 2 and 4 to find its way into the reading.

Step 6: and beyond

The actor continues alternating readings and improvisations. Eventually the process will help the actor become comfortable with the words as a personal means of expressing a complex and compelling thought process.

Variations

1. Getting Unstuck

An actor having a great deal of difficulty with a piece might try breaking the monologue down into small chunks. In every other respect, the exercise would continue as described above.

In this variation, the actor alternates improvising and reading a few lines rather than the entire monologue. The actor should work with whatever size units prove to be most manageable. The

smaller chunks might be as short as one sentence or even a phrase or two. The actor should feel free to explore a phrase or sentence—*tasting*, probing and listening until the thought comes to life inside him or her. Caution the actors to avoid being stuck in one place too long. If the mystery does not reveal itself after a few attempts, it may be best to return to it *after* exploring other ideas. Armed with a greater understanding of the entire piece, the actor can return to what had proven to be a stubborn *knot* with a fresh perspective. Persistence must be tempered with patience.

2. Memorized Monologues

This variation is best saved for advanced actors who know how to avoid locking themselves into line readings.

After the actors are familiar with the exercise, they can use memorized monologues. Obviously this means considerable amounts of the written text will be included in the improvisations. However, the actors should keep digging beneath the written word to make the connection with the character's thoughts. The actors are challenged to break through any superficial interpretations they may have settled for in their preparation. This exercise encourages the actors to vigorously probe the text searching for the character's thoughts because those thoughts will summon his or her words.

Coaching the players:

"Focus on possibilities."

This exercise is a tough one for the actor who always needs to be *perfect*. Encourage the actor to *explore* the monologue rather than *perform* it.

"Put the thoughts before the words."

Urge the actor to focus on the thoughts behind the words, forming the mental images that are part of those thoughts before saying the words.

"Don't stop thinking just because you are reading."

Sometimes an actor delivers a stirring improvisation—filled with action and passion—then dives back into the words and

abandons the images that brought the improvisation to life. Remind the actors to *think*, not just speak.

"Let your thoughts color the words."

The actors must trust their thoughts to color the words. Ask them to notice that during the improvisation they weren't focused on wringing life out of their lines. This workout will help them give up forced line readings.

Add your favorite coaching comments here:

Watch out for the traps:

While memorizing and rehearsing the monologue, some actors get locked into line readings. They etch interpretations in stone. For these actors the improvisations may be pointless if they have memorized the monologue. This is particularly true with inexperienced actors; however, even some experienced actors may have difficulty trusting themselves to improvise freely with memorized words. Work with readings for more spontaneity.

Some actors may interpret this exercise as a license to rewrite the text or to become sloppy with learning lines. The group should understand that the improvisation on the words is an exercise only—a tool for finding the motivations for the words. Once the exercise is over, the actor is responsible for delivering the text exactly as written.

Occasionally the actor who has difficulty with the improvisation will claim that "it doesn't make sense." This person will insist that the actor shouldn't be responsible for words—the writer has provided the text. Assure the resistant actor that the

improvisation is an exploration of the character's ideas, not a writing exercise. The improvisation is not a performance but character research executed in public. Urge the actor to view this exercise as an exploration of possibilities.

Some actors will distort this exercise—using the improvisation as an excuse to avoid the content of the piece. The actor should stay with the character's thoughts, putting them into his or her own words. This exercise shouldn't be viewed as an opportunity to ramble on about various and sundry emotions and attitudes that *might* be relevant. Urge the actor to bring to life the thoughts expressed in the monologue.

Tell me again why we played this game!

"Watching other actors do this exercise helped me see that we often put so much emphasis on getting the words right that there isn't any room for thinking."

"I didn't realize how shallow my understanding of the material was until I was forced to put the character's ideas into my own words. The bottom line was: I didn't *have* any thoughts as the character. I just had all these words I needed to say."

"It was fascinating to watch other actors do this work—to see the material come to life. At first, I thought some of our monologues were dull. However, once the actors uncovered the motivations behind the words, they were very exciting pieces. Now I see that a connection with the character's thoughts will inject life into a piece."

"I finally understand the meaning of putting the thoughts ahead of the words. I used to believe I didn't have time to *think*—now I know better."

"I was surprised by how quickly I learned the lines. And that didn't seem to make sense at first since I wasn't *trying* to learn the words. I recognize now the importance of knowing all the story points. Once I have done that the words come so easily."

17
Listen Out Loud

Use this exercise to improve your actors' listening skills. Some actors pay only minimal attention to other characters on-stage—they work alone. This workout demands a certain amount of listening and that listening produces interaction. During scene study units or rehearsal periods when you are faced with a scene that isn't working, the chances are the actors have stopped listening to one another. Ask them to **Listen Out Loud** for a few minutes.

The payoff:

- **Listening**
- **Interaction**
- **Concentration**
- **Spontaneity**

How to play the game:

The "prop" list

Each actor needs a copy of a short two-person scene.

Choose scenes in which the characters are listening closely to one another, rather than those in which the individuals are lost in introspection.

Each pair of actors uses a different scene. This exercise is useful for cold readings or memorized work. However, on at least one occasion, help the actors listen by giving them scenes they haven't seen before. For some actors, this will provide a revelation. Because they have not become mired in their preparation, the actors find it easier to listen.

The ground rules

The actors work in front of the group, in pairs, one pair at a time.

The actors read or perform their dialogue as written. However, they improvise a response before they say the dialogue as written in the script. The improvised dialogue must either repeat exactly what the other character just said or, at least, repeat the gist of the other character's line. The actors must understand that the point of this exercise is to clearly demonstrate they heard what was said to them.

An example

A sample is the best way to explain this exercise. (The writer's text is in **bold** type; the actor's improvised responses are in *italics*.)

<div align="center">

She

What do you want?

He

What do I want?

Oh, you think you have the world by the tail, don't you?

She

(over-talking)

I think I have the world by the tail?

He

(continuing)

Let me tell you a thing or two, hot shot.

</div>

She

Oh, yeah, let me tell you a thing or two.

Get out of my office!

He

Lady, I'm not about to get out of your office.

I have very expensive tastes. My wife has expensive tastes.

She

(over-talking)

I don't care about your expensive tastes.

He

(continuing)

And that account means a lot to me.

She

(over-talking)

It means a lot to me, too.
Now

Are you going to leave? Or do I have to call someone?

Notice that the actor repeats enough of the other character's dialogue to demonstrate that he or she was listening. The actors do not comment on how they *feel* about what was said. Steer them away from commentaries such as: "It makes me furious that she would say that to me."

Actors who resist interaction will give themselves away in this exercise by referring to the other character in third person. For example:

She

What do you want?

He

How dare she say that to
me? Who does she think she is?

Oh, you think you have the
world by the tail, don't you?

Coaching the players:

Side-coaching is useful in this game. Reminders such as these will help keep the players on track:

"What did you hear?"

Some actors may focus on adding new and, what they hope is interesting, additional dialogue. They may insist on telling what they think or how they feel about what they heard. Urge them to simply repeat what the other character just said.

"Stay with the listening."

Watch for the actors who take time to analyze their response before they speak. They are being cautious to come up with exciting responses. Urge them to plunge ahead and repeat the words they heard while they are processing the information.

"No commenting."

Steer actors away from commenting. Some performers may interpret this exercise as an opportunity to report on their character's state of mind.

Add your favorite coaching comments here:

Watch out for the traps:

Be certain the players understand that this exercise doesn't absolve them of the responsibility for learning lines, nor does it give them license to rewrite the author's dialogue before committing it to memory. Many actors find ad-libbing irresistible and invent dozens of excuses for not learning the script as written. This workout is strictly an exercise; it should never be taken into performance. If, during performance, actors have the impulse to say words such as those in italics, they must channel those impulses into the writer's words.

Some actors will vigorously resist this exercise, complaining that it interferes with their performance. Advise them to set aside performance, for the moment, and focus only on the listening. Remind them this is strictly an exercise designed to have a positive payoff later.

Be sure the actors understand that during any exchange between people there are moments when the participants do *not* listen to one another. This exercise shouldn't be interpreted as a directive to become the kind of actor who plays every scene eyes locked with the fellow players and listening spellbound by every word uttered. This is only an exercise to sharpen listening skills.

Tell me again why we played this game!

"This exercise made me realize that I was just waiting for cues. I wasn't listening. The first time I tried this I couldn't repeat anything that was said to me, because I didn't hear it. I was always thinking about my next line."

"I used to think I had to work out, in advance, every nuance of my line readings. I was terrified that my speeches would come out flat and uninteresting, if I didn't practice emphasis, inflectional patterns, and so forth. Now I see that if I listen, it's almost as if my partner supplies me with line readings. The listening takes the effort out of acting."

"I used to think that being connected meant being attached to what I had planned to do. Watching other people do this exercise

shows me that it means being affected by what the other character is saying and doing to me."

"It reminded me that when I concentrate on listening, it helps me relax. I noticed that if I paid attention to what my partner was saying—rather than obsessing about my fears—the self-awareness disappeared."

Part Three

In Your Seat

"Come, Watson, come! The game is afoot."

Sir Arthur Conan Doyle
Sherlock Holmes:
The Adventure of the Abbey Grange

18
Daydreaming

Although most actors acknowledge that imagination is an essential skill for playing a role, many don't practice forming mental images. As youngsters, they may have been castigated for what was called "daydreaming your life away." Encourage the actors to nurture and strengthen their imagination by using exercises such as this guided *daydream*. One of the actors' primary jobs is to visualize places they have never been, and envision events they have never experienced. The ability to see events in the mind's eye is what enables actors to fill in the specifics of a character's given circumstances.

The payoff:

Imagination
Relaxation
Concentration
Access to emotions

How to play the game:

The leader acts as a narrator, guiding the actors as they picture themselves in an imaginary event. A sample of such a guided visualization is included in this chapter to get you started, but I encourage you to make it your own or create new imaginary events based on this model.

The actors should work seated, rather than lying down. The point of **Daydreaming** is for actors to realize that eventually they can do this type of work quickly and under any circumstances. They also should understand that relaxation and sense memory work should enliven the actors' senses bringing them to the *now* in a heightened state of awareness. Good acting is accomplished by actors who are alert, observant, and thinking clearly.

Basic relaxation

Ask the actors to close their eyes, then lead them through a basic relaxation exercise. Direct their attention to their breathing. They should neither evaluate, nor improve their breathing—just observe the inhalation and exhalation. Encourage them to use their imaginations to see the air moving in and out of their bodies. For example, they might see themselves inhale one color, then exhale another. They might see and/or hear their breath as musical notes moving in and out of their lungs. They could imagine breathing into all parts of their bodies—picturing the air moving into the small of the back, down the buttocks, down the backs of the legs and so forth. Encourage the actors to experiment with techniques to center and maintain their awareness on their breathing.

When the room is still, lead the actors through an imaginary experience. Set a good example by putting the accent on specifics—particularly actions. I can't stress too much the significance of *action*—keep the actors' minds on *doing*. Help them stay focused by pointing them toward the specific physical details of their sensory experience. This exercise is an excellent way to demonstrate to actors that they shouldn't focus on conjuring up emotions. The emotional responses will materialize as an

inevitable by-product of the particular actions within the given circumstances.

A sample daydream

You are walking down a hallway. You cannot see what is at the end of the hall. Imagine the color of the walls, the lightness or darkness around you, the type of floor beneath your feet. Is it tile, hardwood, linoleum, or carpet? What do you hear? Is the air fresh or stale? Continue down the hallway until you come to a door. Visualize the door. What kind of wood is it? Is it plain, or is it ornate? What color is it? What is its size? You decide to open the door. Try the knob. As you feel the texture of the knob, you discover that the door isn't locked. Push the door open, testing the weight and resistance as you do so.

You walk through the doorway and into a room. Look around to see exactly what kind of space this is. Are there sunbeams filtering through venetian blinds, or dust motes floating through the air? Are there curtains at the windows? What is the new texture beneath your feet? Are you standing on carpet now, or hardwood flooring? Is the floor old and worn or new and bright? What color are the walls? Are they covered with wallpaper? If so, note the details of the pattern and colors.

As your eyes become more accustomed to the light in the room, you notice a desk in one corner. Go over to examine it. What is the desk made of? What color is it? Is it an old oak roll-top, a richly polished French Provincial, or a beat up early-garage-sale type? Notice the chair in front of the desk. Is it upholstered? If so, with what—fabric or leather? Is the chair old and marked by time? Are there scratches or tears that catch your attention? Run your hand over the chair, enjoying the texture of the wood, fabric, or leather. Move the chair closer to the desk, paying close attention to the resistance met and sounds produced. Finally, you sit at the desk and notice the desk drawers.

One of the drawers in particular catches your eye and you can't resist opening it. Does it make any noise as you pull it open? Near the front of the drawer you spy a packet of letters. What kind of paper are these letters written on? What color is the paper? Is the color fresh and bright, or is it faded by time? How are the letters tied together—with rough twine, a golden cord, a piece of delicate ribbon, or a dried out rubber band? Do the letters smell of a faded perfume, or do they simply smell of collected dust?

There is a note with the packet instructing you to read the letters. You open the packet. Untie the string, ribbon, or whatever and be precise about the degree of difficulty. Open the first letter. Read the date at the top of the page and the name of the person to whom the letter is addressed. Now I am going to leave you alone to read the letter.

[*After about a minute of silence, begin once again to guide the players through the experience.*]

You have decided to stop reading now—knowing you can come back later and finish the letter if you haven't completed it. Tie the letters into a bundle again and return them to the desk drawer. Push the chair back, stand, and walk to the door. Pull the door open—noting again the texture of the knob and the resistance offered by the door. Walk out into the hall—noticing the changes in lighting, the floor beneath you, the air you breathe, the degree of available light. Make your way down the hall to the exit door that takes you outside. Follow the sidewalk to our building, then into this room and, finally, to your chair.

Return your attention now to your *actual* reality. Listen to the sounds in this room. Feel your chair. You might want to touch a piece of clothing and examine its texture. Notice the temperature in the room. You probably are ready to open your eyes now. When you do, pay attention to individual objects, colors, sizes and shapes. Make comparisons, count objects, organize color blocks, or mentally rearrange objects. Wiggle your fingers and toes; shrug your shoulders; yawn and look around you at your fellow students. If you are still feeling a bit disconnected, you could say hello to your neighbor—maybe even shake hands.

Final notes

After the exercise you should have a group of relaxed, invigorated actors who have a newly validated sense of the potential magic provided by their imaginations.

Add your notes or reminders here:

Watch out for the traps:

Even though the actors work sitting up, some of them may become unfocused and so relaxed they have difficulty returning to the here-and-now. Remedy this by engaging the group in a physical workout. Games from **Playing Catch** (Chapter 6) and **Magical Machines** (Chapter 10) are ideal choices.

Tell me again why we played this game!

"I loved having permission to daydream. I've wanted to do that during role preparation, but worried that I was wasting time. I'm glad to know that I'm *supposed* to use my imagination this way."

"Now if I were playing the character who went into that imaginary room and read that letter, I could talk about those events as though they had happened to me. Supplying all those vivid details made it so real. Thanks to my imagination I feel as though I *have* experienced those events."

"I got so relaxed during the exercise I had a hard time surfacing. However, the combination of this exercise, to relax me,

followed by **Sound-Ball,** to wake me up, worked perfectly. The result was that I had no excess tension, yet I was alert."

"I understand better now how to sustain the authenticity in an imaginary scenario. In the past, when I created imaginary events, I concentrated too much on trying to produce emotions. I ended up creating frustration. During *this* exercise I wasn't thinking about feelings; yet I experienced genuine emotion. I have a new way to get to my feelings now."

"The first time we did this exercise, I liked it because I got to relax. But eventually, it changed the way I define given circumstances and identify needs. I find lots of information in the script, of course, but there are so many facts about my character that I have to supply. I'm getting better at using my imagination to fill in those details."

19
Treasure Hunt

This exercise will change the way your actors think of script analysis. Unfortunately, many actors view this process as a necessary evil instead of a fascinating puzzle that they can solve piece by piece. Not surprisingly, an actor who dreads script analysis will find ways to avoid the odious task until it's too late. However, it's a mistake to assume that every actor who botches a first reading didn't spend enough time preparing. In reality, the problem may be the *method* of preparation, not the *quantity*. It doesn't matter how much time an actor spends preparing, if the method of preparation cripples the imagination rather than sensitizing the individual to the possibilities in the script.

I often see actors prepare for a scene in a way that does more harm than good. Preparatory readings *should* thrust the actor toward a relationship with the scene on every level—physical, emotional, intellectual. This should be an opportunity for the actor to be drawn into the character's inner life. However, some performers use their preparation period to inhibit their imaginations and stifle spontaneity. I watch misguided actors *attack* the script— attempting to pound the material into submission. The tortured expressions on their faces clearly reveal that they are twisting themselves around line readings and manipulating their emotions to fit the words.

The actors are forced by this exercise to look at the script in a new way, since they are allowed to read the dialogue only twice. That restriction thwarts actors who habitually use the preparation

period to wedge the dialogue into their brains—turning the words into mental and emotional handcuffs. Because this approach makes the old counterproductive methods of preparation impossible, the actors have no alternative but to look to new techniques.

While **Treasure Hunt** *can* be a fairly advanced workout, it will prove extremely useful for neophytes. The actors need to understand the value of focusing on exploration instead of performance. Participation in games such as those from **Playing Catch** (Chapter 6) and **Magical Machines**, (Chapter 10) will prepare the group to avoid the mental and physical numbness caused by obsessing on performance. Like **I Want You To** (Chapter 9), this exercise is one of the linchpins of my program. It helps actors learn to read and understand scripts. It is also an excellent way to convey the idea of spontaneity within limitations. Through this work, actors will be brought closer to an understanding of how they can remain free to improvise within the boundaries of the text, the character's given circumstances and the blocking.

The payoff:

- **Understanding given circumstances**
- **Understanding character needs**
- **Understanding dramatic action**
- **Imagination**
- **Spontaneity**
- **Learning lines**
- **Concentration**
- **Interaction**
- **Listening**
- **Scene analysis**

How to play the game:

The "prop" list

Each actor needs:

- scratch paper and pen or pencil
- a copy of a short two-person scene

Make casting decisions in advance. The actors should not be familiar with the scenes.

Some basic terms

For the purposes of this exercise, we will refer to two types of *readings*. Let's call the actor's first silent reading of the script— the one where he or she reads alone, to gather information—*the preparatory reading*. We will call the reading that is done with another actor and in front of the audience *the on-stage reading*.

This is a two-part exercise and each part is divided into several steps. Part I, **The Detective Work**, covers script analysis and is divided into five steps. Step 1 primes the players for the other phases of the exercise. Steps 2 and 4 are group discussions. Steps 3 and 5 are preparatory readings. Part II, **Putting It All Together**, is the on-stage work. Part II is divided into two steps: improvisations and on-stage readings.

Part I—the detective work

Step 1: prime the players

Prime the players for the **Treasure Hunt** with a group discussion designed to clarify the causal relationship between given circumstances, needs, actions, and emotional responses. Help the actors understand that:

- **given circumstances give rise to needs**
- **needs induce action**
- **actions yield, as a by-product, emotional responses**

The particular *who*, *what*, *where*, and *when* of each of our lives (given circumstances) invariably generate our unique desires (needs). Those desires, or needs, inevitably compel us to act, in

other words, do something we hope will satisfy, or at least assuage, our desires. (Of course, the *who*, *what*, *where*, and *when* of our life will determine the specific actions we choose.) The degree to which our actions fulfill, or fail to fulfill, our needs will result in emotional responses.

To help my actors understand this causal relationship, I use an example such as this:

> You return home from a long day at work—a day characterized by malfunctioning equipment, absent coworkers, canceled meal breaks and rigid deadlines that combined to produce sour stomach. You probably have a number of strong desires, some of them conflicting with one another: peace and quiet, sleep, nourishment, relief from the stomach pain, and validation for your Herculean efforts. The degree to which you are successful in carrying out actions that satisfy those needs will produce emotional responses. If the people next door are having a loud party, you won't be a happy camper. If you find the antacid and it works, you will be grateful. If the roast beef you left in the fridge has been eaten by your roommate, you will have a definite emotional response. If your Mom calls and tells you that you shouldn't work so hard—"your boss doesn't appreciate you anyway"—you will be flooded with feelings.

Step 2: discussion of given circumstances

The given circumstances form the character's context. That context includes the physical setting, everything that has happened to the character before the scene begins, and the attitudes the character has adopted as a result of those events. The given circumstances compose the framework within which the action of the scene occurs.

By answering specific questions, the actors will define the character's context. The players should use these guidelines:

- Answer questions in first person, as the character.
- Answers must be anchored in action.

Dry lists of facts will not stir the imagination. The players must create mental images to flesh out their answers.

For example, let's say you are the actor and you identify the other character in the scene as your aunt. Fill in the specifics that will establish a life-like connection with this aunt and ignite your imagination. Is this the aunt who always brought homemade apple pie, but pinched your cheeks and talked endlessly about her gall-bladder operation? Perhaps this is the aunt who always *forgot* to bring a pie and was the individual who insisted on informing your mother that your father was having an affair with his secretary. Or, is this the aunt who told you wonderful fairy tales when you were a child, then was supportive of your dreams to be a pilot and took you on your first plane ride?

The actors should use this technique throughout the examination of the script. Each answer should be fleshed out by connecting specific actions to the person, place, or event. (For help with creating imaginary events review **Daydreaming**, Chapter 18).

Answer these questions to define a character's context:

- **Who am I?**
 What is my job (how do I spend my days), age, educational background, economic status, religious background, physical attributes, goals in life, etc.?

- **Who am I talking to?**
 What is my relationship to the other character in the scene? What is that person's job, age, educational background, etc.?

- **Who are the people we talk about?**
 What is my relationship to the people we talk about? What are their jobs, ages, educational backgrounds, etc.?

- **Where am I?**
 Am I indoors or outdoors? What are the physical characteristics of my space, for example: size, shape, colors, textures, temperature, light, etc.? What have I done here?

- **What are all the places we refer to?**
 What are the physical characteristics of those spaces, for example: size, shape, colors, textures, temperature, light, etc.? What have I done in those places?

- **What time is it?**
 What is the year, time of day, time of year?

- **What happened to me in the moment before the scene?**
 What happened immediately before the first moment in the scene? What is the event that propelled me into this action?

- **What are the events we refer to?**
 What are the specifics of each event alluded to? Who was involved? Where did it take place? When did it occur?

- **What is my point of view, or how does the world work?**
 In other words, what is my interpretation of how the game of life is played? How does one win? What does winning mean? What are the penalties for breaking the rules?

 For example:

 - "Most people do their best so I am always willing to trust a person."
 - "Most people will take advantage of you if they can. I keep my eyes open and make sure I get my share first."

 The *point of view* is the character's belief system, the frame of reference in which the character operates. Each of the convictions that make up the belief system should be anchored in specific action. For every element of a person's belief system there is an event that either inspired the belief or at least corroborates the point of view. People don't consciously choose to *invent* convictions; they interpret their experiences as proof that "this is how the world works."

 The actor should commit to, or internalize, the character's point of view rather than show it to the audience. The characters' belief system will influence the actions taken and that is what the audience wants to see.

Step 3: the hunt—the first preparatory reading

Hand out the scripts and let the actors read their scenes once only. When the participants have read the scenes, instruct them to turn their scripts face down. Give the actors a few minutes to identify the given circumstances.

If you are a teacher, the first time or two you use this exercise, you may want to insist that the actors record their answers and turn them in to you. This will enable you to head off bad habits. When you see that an actor writes notes about everything *but* given circumstances, you will know that person needs some individual help. Otherwise, give the actors freedom to either write down their choices or simply reflect on them.

Step 4: discussion of character needs

Lead a group discussion reviewing the methods for identifying character needs. Encourage the actors to ask these questions:

- What do I need?
- What are the stakes?
- What obstacles must I overcome to achieve my objective?

the need

The actors should ask themselves what motivates each of them, as the character, to *do* or *act*. Each actor finds that motivation by asking, as the character: What do I want? What do I need? What is my objective? What is my intention? What is my goal?

Frequently those questions leave the actor stumped, since people rarely talk to themselves about interpersonal relationships in those terms: *intentions, objectives* and *motivations*. Character needs are often identified by answering questions like these:

- What would enable me to sleep soundly tonight?
- What would convince me that the person I am talking to is a friend, not an enemy?
- What would get this burden off my mind?
- What would I like the other character, or characters, in the scene to stop doing because it frightens me, worries me, saddens me, or annoys me?
- What would convince me that I am in no danger?
- What would end this nagging sense of incompleteness?

- What would it take to send me away from this encounter kicking up my heels or pumping my fist in celebration of victory?
- A favorite of some of my actors is: What would make my day?

Even after having explored questions similar to these, some actors may not be able to identify what the character wants. Assure those actors that all is not lost. Suggest that, when stumped, the actor should commit to an *all-purpose* need that is too general to play indefinitely, but specific enough to spark the emotional engine. I encourage my actors to embrace this need:

- "I don't know exactly why I am dissatisfied with the way things are, but I am. I also know that the other character in the scene is involved in it, and I won't rest until I have satisfied this feeling that something needs to be done."

Playing this all-purpose need at least gets the actor connected with the other character in the scene. That connection then creates a mental and emotional climate in which the individual may intuitively stumble upon his or her character's specific need.

the stakes

The character's needs will compel the character to act, or do, only if the potential consequences of success or failure are extreme. Urge the actors to ask questions such as these:

- What will I lose if I fail, or gain if I succeed?
- What will happen to the people I care about if I fail or succeed?
- How will my life be changed by the outcome of this exchange?
- What will people think of me if I fail in this quest?
- How much longer can I tolerate the current state of affairs?
- What must I face tomorrow if I can't get what I want here and now?

the obstacles

Remind the actors that conflict is essential to drama. The character's quest will engage the audience only if there are obstructions in the character's path. The actors can identify those obstacles by asking questions similar to these:

- What stands between me and what I want?
- What is the other character saying or doing that prevents me from reaching my goal?
- How is the other character slowing me down or distracting me from the pursuit of my objective?

Step 5: the hunt—the second preparatory reading

Signal the actors to turn over their scripts and read them once again, keeping in mind that they will be seeking the answers to the questions regarding intentions or objectives. When the participants have had an opportunity to read their scenes, collect the scripts. Give the players time to focus on answering their questions about character needs.

Part II—putting it all together

Step 1: improvisations

The actors do <u>not</u> pick up their scripts before going on-stage. Instead, they improvise the scene. The objective is for the actors to be clear about the specifics of the scene, not to see how many lines they can remember. That clarity about the action of the scene will enable the actors to put the character's thoughts into their own words.

Step 2: on-stage readings

Immediately following each improvisation, hand the players their scripts and have them do the scene. Because they haven't memorized their lines, the players aren't as prone to thinking about their next line. Because the participants have not had an opportunity to focus on line readings, they are more apt to be paying attention to the action. They are more inclined to listen. The on-stage reading provides the actors an opportunity to:

- confirm their understanding of their scenes
- make a visceral connection with the character's inner life

This combination of improvisation followed by the on-stage reading has proven invaluable in my workshops. I've seen this workout have an amazing effect on actors. Although most of them will resist the improvisation when you introduce it, it is a remarkably effective means of freeing actors. It builds their confidence and teaches them the value of playing moment to moment truth.

Straight To The Reading

When the group has done this exercise several times, and they fully understand the value of the improvisation, experiment with the following variation:

The actors skip the improvisation and go straight to the readings. They pick up their scenes just before they go on-stage. (The actors do not take private time for a practice session with their partner before the reading.) Whatever you do, don't go to this variation until the actors have had some experience with the improvisations.

Adapting this exercise to your situation

I have described the exercise as done in a single long session—since this is the way I use it in my workshops. You can divide the parts to suit your situation. For instance, you might spend an entire meeting discussing given circumstances followed by a session spent discussing character needs. Then you could devote another session to preparatory readings, improvisations, and on-stage readings.

Coaching the players:

You will rely mostly on pre-game and time-out coaching for this game. You will provide much of the guidance by leading the group discussions.

Before the first preparatory reading

Before the actors begin the first preparatory reading, be sure they know that they shouldn't focus on memorizing lines. They are reading the script to discover the crucial elements of the character's story. Encourage them to look for the components that would prepare them to summarize the story. They should focus on the gathering of information, rather than on line readings and emotional responses.

The actor's job is to define the character's given circumstances which will lead to a discovery of character needs. The character needs, then, will produce action. The action, in turn, will move the story forward, while revealing character. This process of *defining* the character's given circumstances and needs is part of what is usually described as *making choices*. Urge the players to focus on discovering all the clues the script will yield rather than obsessing on making *correct* choices.

The actor arrives at these choices based on information supplied by the text. The information in the text is fairly sketchy. The actor uses imagination to fill in the gaps. As an audience, we have neither interest nor motivation to quibble with the actor's choices. We would prefer to be kept busy empathizing with characters and following non-stop action. However, we will find plenty to quibble with if the actor has made *no* choices or choices that have produced ambivalence. Urge the actors to make strong choices based on what they *do* know and stop worrying about what they *don't* know.

Before the improvisations

Before the improvisations, remind the players that they shouldn't struggle to recall lines. They should pay attention to what is happening—to the interaction between themselves and the other character. They should concentrate on whether they are getting closer to attaining their objective or losing ground in the struggle.

Before the on-stage readings

Before the on-stage readings, urge the actors to keep their focus on listening and playing the action. Encourage them to trust their preparation.

Call to mind the principles of other games that are more physical. For example, coach the actors to play this game the way they play **Sound-Ball** (Chapter 6). I implore them to *keep their eye on the ball*. I remind them that they shouldn't manhandle the scene—they should simply *catch the ball and throw the ball*.

Additional notes

Watch the actors during preparatory readings. Study their body language. You will gain insight into each actor's process, discovering which of the players are creating the biggest problems for themselves. It's a joy to note the palpable physical changes as the actors repeat this exercise. Gradually, they come to understand the legitimate reason for the preparatory reading. Inevitably, the clarity of purpose produces confidence. Relaxation replaces the tension that resulted from confusion and panic.

Obviously, it is not the intention of this exercise to discourage actors from repeated reading of their scripts. The purpose is to guide them toward *more purposeful* reading. After working on this exercise for a time, actors see the undeniable results and they begin to investigate their scripts without being nagged. Instead of just going through the motions of reading the script, they are eager to conduct these inquiries, because they have discovered that the information is vital to their experience.

Add your favorite coaching comments here:

Watch out for the traps:

Many actors will be intimidated by this exercise. Some will be certain that they can't possibly grasp the key elements of even a short script when limited to such an abbreviated preparation. Assure the actors that this is an *exercise* and encourage them to develop a spirit of adventure. This is an excellent opportunity to communicate the meaning of exploration, of taking risks.

In the case of the improvisation, be certain your players understand that this exercise is **not** a license to become sloppy about learning lines. The improvisation of the scene is an opportunity to drive the action into the viscera. It is **not** a substitute for learning the lines as written.

You will see some of that glazed-eye acting—actors who turn all their attention inward and attempt to read the words off the screen in their mind. Urge these players to *forget* the words and focus on *doing*.

Tell me again why we played this game!

"I thought I would die when you told me my first opportunity to read the scene aloud would be in front of the group! I was amazed at how easily I got the words off the page. I had a sense of purpose that freed me."

"The first time we did this exercise I was in a panic, but the next time I looked forward to my preparation because I knew it would work."

"It's not as if I hadn't paid any attention to the *who, what, where, when* questions in the past—they just were buried by the obligations to making the scene work."

"Now that I have formed the habit of preparing this way, I find it makes it much easier to learn my lines. Now the words have something to stick to."

"Now I find it very exciting to get up there with my partner and plunge into the scene. I'm confident that, because I know what my needs are, my mind and body will gravitate toward

action. I've discovered that I naturally search my consciousness for strategies, then make adjustments to the other actor's actions."

"I realize how much time I used to waste. I would frantically go over and over the scene, trying to figure what I should be feeling."

"I love watching the other scenes. They are so action-filled. People are really listening. Of course you have to listen. You just don't know the words well enough to not listen."

"This exercise has made a big difference in my auditions. Even if I have very little time to prepare, I am confident that I can work quickly because I know how to spend my time productively."

"I know I listen better just because I haven't had an opportunity to become obsessed with listening to my own voice. That's what I used to do during my preparatory reading—rehearse line readings in my head. Now I've learned a better way to spend my time."

"I'm beginning to understand dramatic action. I can see that when I commit to the character's unfulfilled desires, the desires will compel me to act."

"It's the combination of this exercise with **I Want You To** that has clarified dramatic action for me. I finally got it that first, my character must experience needs, then, second, there must be a response to those needs. It's not enough for me to recognize the wants. What interests the viewers is the *actions* precipitated by the needs."

"Acknowledging the obstacles in my character's path is critical. When I do that I naturally scramble for my words because they are the tools that *may* help me overcome the obstacles."

"I love this exercise. Now I have a road map!"

20
Eight Line Scenes

This game is a hybrid. Since it provides the players experience in scene analysis, it is similar to the exercises in Part III. However, it is more playful than those exercises and the actors do this work *on their feet*. It follows **Treasure Hunt** because of the similarities in themes.

The focus in **Eight Line Scenes** is on the importance of identifying given circumstances. The actors learn by practical experience that the particulars of the character's context will determine the specific nature of the character's needs. Those particular needs can be relied upon to compel the character to commit certain acts, or do certain things, that the character hopes will satisfy those needs. The extent to which those actions succeed in meeting the character's needs will result in emotional responses.

In this game, the actors use eight lines of dialogue to test this hypothesis. The actors establish different sets of given circumstances for the same eight lines, then play out the action evoked by the needs that arise out of that context. It rapidly becomes clear to the actors that with each new predicament, they interpret what is said to them in a different way. For example, what one hears may seem benign in one context, but threatening in another situation. What the actor hears, or thinks he hears, produces specific responses and those responses color his dialogue.

The payoff:

- Understanding given circumstances
- Understanding character needs
- Spontaneity
- Listening
- Imagination
- Interaction

How to play the game:

The "prop" list

Each actor needs a copy of a short two-person scene similar to the samples at the end of this chapter. Each pair of actors will use a different scene.

The ground rules

The actors work in pairs, one pair at a time, in front of the group. When the two actors are on-stage, give each player a copy of their scene, assign the roles, and let the actors read the scene aloud. Note that the actors do not get a copy of the scene until they are on-stage.

Lead the actors through the process of identifying the given circumstances in the scene. (See **Treasure Hunt**, Chapter 19, for a detailed discussion of the questions used to define given circumstances.) Alternate between the two players for the answers.

For example: Ask Player #1 to supply the relationship—thus covering *who am I?* and *who am I talking to?* Then ask Player #2 to determine *who are we talking about?* In most of the sample scenes, there are only oblique references to other characters. However, I always ask the actors, "Who is the character you would eventually mention if you extended this conversation?" Encourage the actors to notice that other relationships and events have had an impact on the action in this scene. These two characters do not exist in isolation. Next, Player #1 provides the

where?, Player #2 supplies the *when?*, and Player #1 defines *the moment before*.

This questioning should move at a rapid pace. The players don't negotiate the answers. Player #2 accepts Player #1's definition of the relationship, even if he or she has a *better* idea. This workout is a challenge for actors who have trouble remaining flexible.

Allow the actors a beat during which they commit to the given circumstances. There is *no* private conference between the actors before playing the scene and there is no rehearsal.

After the actors play the scene, lead them through another round of supplying given circumstances. This time let Player #2 begin with the relationship, then continue the process of alternating through the questions. Guide the actors toward choices that are substantially different from those made in the first round. Encourage the actors to establish a relationship, power distribution, moment before, a where, and a when that will cause the words they hear to take on contrasting meanings. Be sure they pay particular attention to relationship and setting—choices that determine the dispersal of power between the characters.

A variation

Assign partners, then give scripts to each pair of actors. Each pair prepares three versions of the scene. Urge the actors to strive for sharply differentiated choices for each version. Remind them that they want the other character's dialogue to sound different to them each time. They will *hear* what the other person says within a unique set of given circumstances. Allow the pairs a conference period of about ten minutes for preparation. During their conference, the actors determine the given circumstances using the same alternating technique they used when they prepared in front of the group.

Remind the players that they shouldn't waste any time negotiating settlements. The goal is for each actor to remain flexible and adjust to the choices provided by his or her partner.

Coaching the players:

Rather than the usual side-coaching, you will guide the actors through the process of defining given circumstances and provide notes before and after the readings.

These are some of the comments you will find yourself repeating often.

"Be specific."

The actors must avoid generalization. Be sure they fill in the particulars that make the choices meaningful. For example, challenge the choice when they set the scene in "a restaurant." "Which restaurant? Is it a coffee shop or a five-star French restaurant? Have you been here before? What happened when you were here before?"

"Make strong choices."

Encourage the actors to concentrate on strong choices—choices powerful enough to infuse these innocuous lines with meaning. Help them see that the more vivid and personal the choices are, the more effectively they drive the action.

"Justify, don't negotiate."

The first time the actors play this game, they may insist that they need time to discuss their answers with their partners. Discourage negotiations and keep the exploration moving at a rapid clip. Urge the actors to take advantage of this opportunity to practice justifying choices that may be thrust upon them.

Add your favorite coaching comments here:

149

Eight Line Scenes

Watch out for the traps:

Actors on-stage and in the audience will notice how quickly actors *set* a line reading. The players always supply circumstances for the second reading that they *think* are very different from those provided for the first reading. In reality, they may have unintentionally provided particulars that justify repeating their previous line readings.

Some players will have a tendency to make choices that are safe. For example, someone is sure to choose, "We are just friends"—the implication being there *is* no power struggle. While that may be true of some relationships in a piece, the actor who makes that choice has missed an opportunity to inject tension into the scene.

Encourage them to ask specific questions that more clearly define the relationship:

- Whose car do we usually take?
- Who decides what movie we will see?
- If we are roommates, who had the apartment first, or who has the bigger bedroom?

Tell me again why we played this game!

"I'm beginning to understand that it's not so much a matter of making the *right* choice as making a *strong* choice. When I watched actors do a scene three times, committing to different choices in each playing, all the choices looked *right*. The trouble with my choices wasn't so much that they were wrong—the real problem was that I didn't fully commit to them."

"This exercise helps me recognize that I don't have to work at *line readings*. When I commit to the given circumstances, I begin to experience needs. Those needs and circumstances influence what I *think* I hear when the other character speaks. What I think I hear will influence my subsequent thoughts and I cannot deliver my lines without being influenced by those thoughts. It certainly takes a lot of the work out of acting!"

"After doing this exercise I won't be tempted to skim over the issue of relationships. I was amazed how different the other character's lines sounded to me after I committed to a different connection. I understand now how significant it is to determine the power distribution—it changes everything."

"This workout helped me straighten out my thinking about the *moment before*. It was so obvious that changing the *moment before* transformed my needs and my expectations. I'm beginning to understand how the elements of given circumstances are related and how they affect my listening."

"While watching other people work I came to understand the truth of the statement: 'character is revealed by action.' First, I could see that each set of given circumstances created distinct needs, and altered needs produced different actions. Then, it was clear that when the actors executed new actions different characters were revealed. I am confident now that if I play action I don't have to worry about showing character."

"I was amazed at how much action the scenes contained. The words are so innocuous. It certainly points out that it isn't just about the words. It's about the actions the words deliver."

"After we changed the circumstances for the second scenario, I was sure the words couldn't possibly work. But they did! This exercise helped me understand the role of given circumstances."

Sample scenes:

Several sample scenes are included here for your use. These scenes are deliberately vague and innocuous enough to respond obviously to differing actor choices. You could cast any sort of character in almost any type of situation and give them these words. When you create additional scenes for this workout, keep these guidelines in mind. It is also advisable to stay with short lines and short scenes.

Scene #1

A

You're late.

B

Sorry.

A

Is that all?

B

I couldn't help it.

A

I understand.

B

I thought you would.

A

Let's get started.

B

Fine.

Scene #2

A

You're sure about that?

B

Absolutely.

A

I'm surprised.

B

Really?

A

Really.

B

You should have asked me.

A

I wish I had.

B

Me too.

Scene #3

A

Are you ready?

B

I guess.

A

You're not sure?

B

Well, no.

A

Take some more time.

B

No, we may as well start.

A

Whatever you say.

B

Right.

Scene #4

A
Which do you prefer?

B
I like them both.

A
But which do you like best?

B
I like them equally.

A
Come on. Tell me.

B
I'm telling you.

A
You don't want to tell me.

B
I told you—I like them both.

Scene #5

A

So you'll think about it?

B

Sure.

A

And you'll let me know?

B

Sure.

A

That's all I ask.

B

I'll do it.

A

Great.

B

It's important.

Scene #6

A

What do you think?

B

I'm not sure.

A

You're the boss.

B

Am I?

A

Aren't you?

B

I guess.

A

Thanks.

B

You're welcome.

Scene #7

A

Here they are.

B

Finally.

A

I guess we should start.

B

Do you need me?

A

Of course.

B

You're sure?

A

Definitely.

B

Okay.

Scene #8

A

I don't think I can.

B

Of course you can.

A

No—really.

B

Just try.

A

Now?

B

Yes, now.

A

Will you help?

B

Of course.

Scene #9

A
So?

B
So what?

A
Did you tell him?

B
I couldn't.

A
It's your responsibility.

B
I tried. I can't.

A
Who's going to do it?

B
I don't know.

Scene #10

A

Will you give her these?

B

Sure. Any Message?

A

Just tell her they're from me.

B

Can't you stick around?

A

No. I've got to run.

B

She'll be back any minute.

A

I'm running late.

B

She'll be sorry she missed you.

21
Name The Actions

This exercise will point the actors toward *doing* and away from *emoting*. When starting to prepare a scene, many actors prefer to focus immediately on the results: the emotions. They are what I call *feeling junkies*. Trying to wean these actors off playing emotions is sometimes about as much fun as sticking your hand in a hornet's nest. Nevertheless, it's worth it to persevere until the actors know that:

- human beings are driven to action by their unfulfilled desires
- emotions are the by-products of action
- it is the doing, most of all, that attracts and holds the attention of an audience.

Some actors will love this workout, recognizing immediately its usefulness, while many will find it tedious or confusing. However, even the actors who are the most distrustful of this workout will soon be won over. They will discover that focusing on action does not produce acting that is cold and bloodless. On the contrary, the more action-packed the scenes are the more passion will be aroused.

When I was in the Department of Drama at the University of Texas in Austin, Dr. Francis Hodge headed the directing program. Fran Hodge was relentless in his determination to teach the significance of action. It seemed to me that I wrote verbs morning, noon and night. I wrote verbs until they filled my dreams—verbs

run-amok, chasing me down dark alleys. I will be eternally grateful—nightmares and all.

The payoff:

- **Understanding dramatic action**

How to play the game:

The "prop" list

- Each player will need a copy of a scene.

 Short scenes are best for this workout. In one version of this exercise, all the actors work on the same scene; in another version, the actors work in pairs with each pair using a different scene.

- The actors will need paper and a pen or pencil.

 If the actors are working on scenes from screenplays or teleplays, they will have plenty of room in the margins for notes. If, however, the scenes are from plays, the actors will need scratch paper for notes.

Prime the players

The actors will need a considerable amount of pre-game coaching to be successful with this exercise.

Lead a group discussion to clarify how active verbs describe something that can be *done* to another character. To get the most out of this exercise, the actors need to know the difference between transitive and intransitive verbs.

- A **transitive, or active,** _verb_ is one that expresses an action that is carried from the subject to the _object_ and requires a direct object to complete its meaning. (The mother hugged her child.)

- An **intransitive** verb, on the other hand, doesn't take an object. (The child slept. Or, the child cried. Or, the child became irritable).

The actors also need to understand that much of the dramatic action in a scene is mental rather than physical activity. The characters—always engaged in doing—accuse, question, congratulate, placate, and vilify one another. Each uses mental energies to cheer, embarrass, woo, or stupefy the other. One character reaches for words because of a yearning to create within the other character an understanding of his or her gratitude, pain, adoration, or confusion. Another uses words to create images in the other's mind—images of beauty, desolation, serenity, or tomfoolery. The characters use their dialogue to negotiate settlements, solve mysteries, resolve predicaments, and defend their actions. They offer and reject proposals, try to change each other's minds, and attempt to seduce one another. They fight battles and negotiate truces. From one moment to the next, the characters are intertwined in an ever changing web of action and reaction, giving and taking, advancing and retreating, tension and release.

The ground rules

This exercise requires the actors to explore the reciprocal action in a scene. The actors study their scripts, then describe the actions each character *might* pursue during each of their speeches. Keep the emphasis on the exploratory mode. It's a good idea for the actors to list at least three verbs describing the actions that *could* be played. Warn them to avoid locking themselves into a specific action that must be played regardless of whatever else may happen. The exercise should never be misinterpreted as an excuse for acting alone. The players must always leave plenty of room for spontaneous interaction.

Encourage the actors, for the purposes of this workout, to focus on transitive (active) verbs to describe their actions. Most actors will naturally gravitate toward choosing intransitive verbs because those choices allow them to focus inward and avoid reciprocal action. The active verbs will keep their attention focused outside themselves and direct them toward the sort of actions that will arouse responses. Active verbs describe actions that are likely to create resistance and invite participation or reciprocal action.

Some tips

It may take some coaching to produce active verbs. Let all the actors collaborate in compiling a sample list of transitive verbs before the actors examine their scripts. Urge them to visualize the actions as they are named. The players should focus on vivid action-filled images. They should think in terms of <u>lifting</u> one another up, <u>cornering</u> one another, <u>holding</u> someone back, <u>pulling</u> someone out of the fire, <u>covering</u> another with laurels. They will enjoy outdoing one another with more and more action-oriented verbs. This list, then, will stimulate their thinking each time they name actions.

Since this exercise has a classroom feel to it and covers the basics of the craft, it will be particularly useful to the teacher. However, the director or actor/group leader also will discover ways to suit the workout to individual needs. The director will probably use the approach with a couple of actors at a time, focusing on the problem areas in a particular scene. The actor/group leader will find it useful to make the workout as playful and collaborative as possible.

Let's play

Use the following variations to help actors learn to identify actions:

1. Team Effort

With inexperienced actors it is useful to have all the players work on the same scene the first time they do this exercise. Choose a short two-person scene. Each actor imagines playing both roles and names the action for both characters. For this version of the exercise, the group collaborates on choices—each player volunteering suggestions for the best way to describe what the character might end up *doing* at that point in the scene.

2. Private Search

For this version, cast the actors in short two-character scenes. Allow the actors private time to explore their scripts, naming the actions for both characters. The actors could examine scenes they are already working on or scenes they have just been assigned.

After the analysis period the players should perform the scenes in front of the group.

3. Real Life Interaction

The actors name the actions in a real-life encounter they observe. The actors study real people interacting with one another, noticing that the involved parties are always doing things to one another rather than attempting to produce emotions.

4. Checking Up On The Pros

The actors study a rented, or taped, movie or television show in order to better understand dramatic action. They name the action played by the characters on screen just as they named the action in their scenes. (I have recommended using filmed or taped work for this game because this is a practical means for allowing the actors to view repeatedly the same piece of work. In some situations, the group may find it practical to study a theatrical production for this exercise.)

Finally

Naming actions, like any other technique for analyzing scripts, is not a panacea. However, it will make the actors more sensitive to the need for reciprocal action and less likely to settle for endless, empty words. With their awareness of action heightened, the actors are more apt to focus on doing instead of feeling. Urge the actors to analyze the action in scenes that they have worked on in the past and scenes they watch others play. The value of this exercise lies in repetition.

Coaching the players:

Pre-game coaching is crucial for this exercise. Be sure the actors are choosing transitive verbs. Some actors will struggle because, while they can identify verbs, they have trouble telling the difference between transitive and intransitive verbs. Others will choose adjectives rather than verbs. Those who opt for adjectives are confused. Instead of focusing on action, they are focusing on thoughts and feelings.

The point of this exercise is to encourage the actors to pay attention to the action or doing in the scene rather than the state of mind or being. The actors should test their descriptions to be certain they are action verbs. For example, if an actor picks *angry* for the description, ask the actor to identify the object of *angry*. Whom or what will the character *angry*? John can *insult* or *threaten* Tom, but John cannot *angry* Tom. The point of this script exploration is to discover what the characters do to one another.

Add your favorite coaching comments here:

Watch out for the traps:

Some actors will skate through this one. They will accumulate a list of acceptable verbs, then mindlessly repeat them to fulfill the minimum requirements of the exercise. Don't despair. Even these people will get something out of the work, if they do it often enough. The simple repetition of the drill will at least make it clear to them that action ranks high on the priority list.

Some actors will interpret this exercise as a mandate to act alone. They will fall in love with playing verbs, but ignore the essential concept of reciprocal action. If an actor has fallen into this trap, it will show up during the scene work segment that follows the workout. Help the actor understand the meaning of *reciprocal* action. This individual may be identifying the actions of his or her character and ignoring everyone else's. Remind the actors that actions played in isolation, no matter how interesting

they may have seemed during preparation, will not substitute for interaction.

If you shift immediately to scene work after this exercise, don't be surprised to find some players completely tied up in their heads. Many actors are somewhat susceptible to *paralysis by analysis*. This workout may initially backfire with some performers. It may encourage them, the first few times, to watch themselves even more than usual. They may think they need to be vigilant—checking to see that they are playing the verbs they listed. Naming the actions is intended to stimulate interplay between the characters, not program robotic actions. Use an interactive game, such as **Sound-Ball** (Chapter 6), as a transition between analysis and the scene work. It will help to get the players back into their bodies.

Tell me again why we played this game!

"It really helps me to keep doing this work—even though it makes me crazy. More and more I am thinking about what my character wants or what my character is *doing* instead of what my character is *feeling*."

"This exercise has taken some of the angst out of acting for me. When I give myself, as the character, an action to carry out, a lot of other things fall into place."

"I never really *got* this exercise until I started studying movies on tape. Because I could watch a scene several times, I could finally get past the dialogue and the emotions. Then, I could see that what the characters were doing could be described with verbs."

"The first time we did this exercise I got in more trouble than ever. I watched myself play the scene to be sure I was doing what I had decided to do during preparation. Now I pay more attention to the other character—observing the effects of my actions."

"It's so important for me to pick several verbs that might describe my actions. Then, I have to remind myself that these are *possible* descriptions of my action. If I don't do that, I start going

on automatic pilot—just playing those verbs, all by my lonesome. Who needs the other actors, right?"

"I still have trouble coming up with verbs that I believe accurately describe my characters' actions. However, even when I'm sure I have failed miserably, the effort pays off. Focusing on active verbs forces me to think about directing my energy outside myself. I have seen a tremendous difference in my scene work since I started including this step in my preparation."

22
Finding The Triggers

This exercise helps the actors more clearly understand why the characters say what they say. It is an excellent way to teach actors how to make the words their own. Once the players get the hang of this puzzle-type game, **Finding The Triggers** will revolutionize the way they prepare for and play their parts. Learning their lines with this approach they avoid rote memorization, which frequently breaks down under the pressure of performance. This game promotes life-like listening and genuine interaction. Because the actors will see a profound difference in their scene work, they will soon make this technique an integral part of their preparation.

The payoff:

- **Scene analysis**
- **Learning lines**
- **Listening**
- **Understanding dramatic action**
- **Understanding interaction**

How to play the game:

The "prop" list:

Each actor needs:
- a copy of the scene to be analyzed
- a pen or pencil.

The first few times you use this exercise, it is best to have all the actors working on the same short two-person scene to facilitate group discussion. If the actors are going to do on-stage readings of the scenes after the exploration, choose a scene you can easily cast from the group.

Prime the players

Actors are admonished over and over to *listen*. Unfortunately, they often translate that advice into a mindless sort of listening. The confused actors either hang on every word spoken or hear only cues. They turn their characters into robots that deliver lines on cue. Understanding the trigger concept frees actors from their misconceptions about the listening process and infuses their on-stage conversations with purpose and vitality.

For this exercise, the actors will examine a script discovering how the characters' lines are connected to one another. Prepare the players to locate the trigger for each speech in the scene. Lead a group discussion to be sure the participants are focusing on these principles in their examination of the script:

- A trigger is the key word or phrase in the dialogue that activates a thought process that, in turn, results in dialogue.

In a conversation, everything that is said can be linked to an activator—a stimulus that fired the thought process. One person says something to another. What the person says activates a thought process in the mind of the listener. Then the listener frames a response that articulates the thought.

- Don't neglect the obvious triggers.

 Often a character repeats a word, or a phrase, spoken by another character. The repetition is a conscious, or unconscious, decision to indicate: "I heard what you said." It may indicate that that word, or phrase was the trigger. Spotting those obvious triggers will speed up the search.

 There are a couple of examples of obvious triggers in this exchange:

 > **Dean:** Well, I guess you've <u>got</u> <u>me</u> on that one.
 > **Maria:** <u>Got</u> <u>you</u> how, Dean?
 > **Dean:** My story didn't make much <u>sense</u>, did it?
 > **Maria:** No <u>sense</u> at all.

 Notice that by repeating the very words he used, Maria erases any doubt in Dean's mind as to whether or not she is paying attention.

- The trigger for a speech is not always located in the immediately preceding speech.

 Sometimes words or phrases activate a thought process, but the character suppresses the impulse and postpones the response. The response simmers during a couple of exchanges, then is articulated several speeches later.

 For example, notice the triggers in this exchange between brothers:

 > **Ray:** You don't have a snowball's <u>chance</u> now.
 > **Aaron:** I don't get it, Ray. A while back she thought I hung the moon.
 > **Ray:** (laughing.) You blew it little brother. Big time.
 > **Aaron:** What the hell is so funny?
 > **Ray:** You!
 > **Aaron:** Yeah, well you aren't doing so hot yourself, big shot.
 > **Ray:** Hey man, don't lay this on me.
 > **Aaron:** You really think I don't stand a <u>chance</u>?

Aaron's impulse to quiz Ray about his chances had simmered during several preceding speeches and this line has no real connection with Ray's line, "... don't lay this on me."

- Although the trigger for a speech is frequently located in the immediately preceding speech, it is *not* necessarily at the end of that speech.

The hair-pulling director shouting for the umpteenth time, "Pick up the pace, folks," is dealing with actors who believe that triggers are always the last words of the preceding speech. Those misguided actors dutifully memorize the last couple of words of the speech preceding theirs. Then, rather than listening to the other characters, they wait for their cue.

In real life conversations, we don't listen to one another that way. In some cases, the last words or phrase spoken to us may trigger the thought we end up expressing. However, what often happens is the stimulus is fired but, for one reason or another, the response is delayed. The response may be delayed simply because of the split second it takes the listener to translate the thought process into words. Or, the listener may postpone the verbal response until the speaker completes his thought out of politeness, fear, or self-doubt. An actor must not assume that the trigger is inevitably composed of the last words in the speech immediately before his or her speech.

For example, notice the delay between the trigger and the response it evokes in this exchange:

> **Margie:** She's trying her best to get through to you, Will. But you keep <u>pushing</u> her away. Sooner or later she's going to give up on you.
>
> **Will:** She's the one doing the <u>pushing</u>.

Will's response is activated in the middle of Margie's speech. He stews—only partly listening as she continues—then finally gets the opening for the response he wants to make.

- In some cases, a key word or phrase more accurately *re-ignites* a thought process.

Often the groundwork was laid for the firing of a stimulus before the scene began. An idea, formed some time ago, may simmer, then be touched off again by a trigger fired during this exchange.

For example, notice the connections between the first two lines in this scene between a mother and daughter.

> **Helen:** Whatever you say.
> **Callie:** Tell me I'm wrong. Go ahead.
> **Helen:** I didn't say you were wrong, did I?
> **Callie:** You don't have to say it. I know that's where you're headed. I can see it coming. This is where you tell me I'm ruining my life, right?
> **Helen:** How do you know what I'm thinking?

Helen is caught off guard because, in her mind, Callie's response has nothing to do with "Whatever you say." Obviously Callie thinks she recognizes "Whatever you say," as a signal that her mother is about to return to a familiar refrain. Callie's response was actually activated in the past and is touched off again in this exchange.

- Often more than one stimulus is fired in a speech.

In some cases the stimulus is fired, but the listener sits on the impulse—itching to speak, waiting for an opening. Before that opening occurs another stimulus may be fired which sets in motion a flow of ideas so compelling they cause the listener to momentarily abandon the first thought.

For example, notice the triggers in this exchange between two neighbors:

> **Elsie:** Saw poor Frances Potts yesterday. She sends her best. Seems her daughter is moving back here. Laura—the one who went to school back East.
> **June:** Well, well—back to our sleepy little village.

> **Elsie:** I suppose the big city wasn't what she hoped it would be.
>
> **June:** How did Frances look? Is she getting around any better?

Elsie's first speech triggers two separate thoughts in June's mind. June articulates the first one almost immediately, but delays the response to the second one. Rather than listening to Elsie's second speech about the big city, June's mind is filled with images of Frances Potts and her physical problems.

- A trigger may be so powerful it drives several speeches.

Occasionally the stimulus that is fired is more like a blast of TNT. The blast may set off such a volcanic eruption of ideas that the receiver of the stimulus delivers a virtual monologue. Meanwhile the character who set off the explosion may attempt to reestablish dialogue.

For an example look at this scene between a husband and wife:

> **Hume:** He doesn't set foot in this house until he makes it right. You tell him his things will be on the porch ...
>
> **Cora:** I will tell him no such thing. This is his home for as long as I'm breathing.
>
> **Hume:** If you don't tell him, I will.
>
> **Cora:** I will not let you drive him away again.
>
> **Hume:** I'm right and you know it.
>
> **Cora:** He is my son and nothing is coming between me and him. Certainly not your pride, your stubborness.
>
> **Hume:** Nothing you can say is ...
>
> **Cora:** I listened to you last time and I never stopped regretting it.
>
> **Hume:** He's got to learn ...
>
> **Cora:** You and him will have to work things out between you. But, I'm his mother and he's my son and nothing's bigger than that. And you're going to talk to him, you understand? And if

> you two can't make things right, then you can
> put my things on the porch, too!
> **Hume:** Don't threaten me.
> **Cora:** You heard me.

Notice that if you eliminate all Hume's lines after his first one, it makes little difference to Cora. His first statement sets her off on a virtual monologue.

- For this exercise, focus only on the textual triggers.

During the playing of the scene, numerous activators will be fired. Those activators include: physical actions, gestures, facial expressions, and emotional color given to the words. Those levers will have a powerful effect during the playing. However, they do not provide as reliable an understanding of the flow of ideas as the textual activators.

The description in the script may say "he shrugs his shoulders" but what happens if that actor doesn't shrug his shoulders? If the other actor has learned his or her lines depending on that gesture as a trigger, a line will probably be dropped. Although an actor cannot be guaranteed that another performer will memorize and deliver lines as written, it is a safer bet than relying on gestures. The actors should focus on physical activators during the preparation period only when they have no other choice. Trust the textual triggers to discover the flow of ideas expressed by the characters. Trust the physical triggers to add color and nuance to the dialogue.

- A trigger pinpoints the moment a thought process is set in motion *not* the way the line should be said.

This script analysis is not encouragement for actors to act alone. It should help the actor see how his or her character's words and thoughts connect to the words and thoughts of the other characters. The actor, working alone with the text, must limit his or her conclusions to a narrowing of possibilities. The precise nature of the response should be discovered in the playing. The actor should remain open to the emotional heat or pressure that is created by whatever interaction is taking place

when the stimulus is fired. That heat or pressure will shape the line reading. Locating triggers should inspire, not inhibit, spontaneity.

The search

Give the actors a period of time to examine their copies of the scene, marking triggers. The actors examine the characters' speeches, one speech at a time, identifying the key words or phrases that trigger the ideas articulated in that speech. For the purposes of the group discussion, the actors should imagine that they will be playing *both* roles. The actors may find it most effective to focus first on finding the triggers for Character A's dialogue then repeating the process for Character B's lines.

Sharing discoveries

When the actors have had time to complete their investigation of the script, lead the group in a discussion centering on their discoveries. During the discussion alternate between the characters—focusing on Character A, then Character B. In many cases, there will be varying opinions about what qualifies as the trigger. There is no need to determine which is the *correct* answer. However, the discussion provides an opportunity to point out the effects of certain choices. For example, while one choice will slow the tempo, another will accelerate it. In addition, some choices promote more listening between the characters while others cause the characters to detach from one another. The actors should be aware of the consequences of their choices.

The readings

After the discussion, the actors do on-stage readings of the scene in front of the group. One pair at a time, they read the scene discovering what happens as a result of having sensitized themselves to the triggers embedded in the dialogue. The focus should be on listening and exploring, not *setting* a performance.

As a by-product, this exercise provides a valuable opportunity for the actors to watch other actors read the character they are playing. Discourage the actors from thinking of this as competition. Encourage them, instead, to notice the variety of interpretations given to the role. The exercise is not designed to discover the *correct* way to play a role. It should help each actor find his or her unique expression of the character.

Coaching the players:

You will provide continuing guidance during this game by referring the actors back to the guiding principles for recognizing triggers.

Add your favorite coaching comments here:

Watch out for the traps:

Some actors will drive themselves—and everyone else—nuts by insisting that there must be perfect answers to each question. There may be more than one useful answer. Knowing how to make these choices is more important than agonizing over the perfect decision. Obsessing on the rigid pursuit of perfect answers will only inhibit the discovery process. Ideally, the actors will learn to welcome the little detours that lead them to unexpected discoveries.

Tell me again why we played this game!

"This exercise has made a major difference in the way I learn lines. I'm no longer struggling with lines that, at first glance, seem to come from out of nowhere. I used to drill those speeches over and over; but, when the cue came, I would be blank. I know that I went blank because I missed the trigger. Now I look for triggers first, then learn the lines."

"It was an eye-opener to see all the other people read the role I was reading. At first, I got caught up in comparing. I was thinking: 'Oh, I should have done that;' or 'This is so much better than my reading.' After a few readings, I got over that and started realizing that there were a lot of ways to interpret the role. That knowledge frees me to explore bolder choices."

"I used to rush through my lines because I had heard 'the scene is dragging' so often. The scene was dragging because I was ignoring the triggers. I thought I didn't have permission to go into action until the other character stopped talking. Now I know that if the scene is dragging I can go back and look at the triggers I identified. When I adjust those, the tempo will pick up. I can stop worrying so much about tempo and listen."

"This exercise has completely changed the way I look at a role. Now with each scene I see the story so clearly. Everything seems to connect and make sense."

"I listen much better when I have done this preparation. I know that if I allow my actor problems to distract me, I won't hear my triggers."

"I feel much more confident about auditions since I started finding triggers. Now I feel completely grounded in the story and I know that I won't get rattled. I know that my lines are solidly connected to what the other characters are saying, so I can trust myself to listen."

Appendix

More Information

"Knowledge is of two kinds. We know a subject ourselves, or we know where we can find information upon it."

Samuel Johnson
Quoted in: James Boswell, *Life of Samuel Johnson*

Cross-Reference Chart

Games & Exercises

The Payoff	Bending the Rules CH. 14	Can You Top This? CH. 13	Daydreaming CH. 18	Eight Line Scenes CH. 20	Finding the Triggers CH. 22	Group Juggling CH. 11	I Want You To CH. 9
Access to Emotions			•				
Concentration	•	•	•			•	•
Emotional Range							•
Ensemble	•					•	
Freeing the Body	•						
Getting Out of Heads and into Body	•						
Imagination	•	•	•	•			•
Interaction	•	•		•	•	•	•
Learning Lines					•		
Listening		•			•	•	•

Games & Exercises

In Your Own Words CH. 16	Listen Out Loud CH. 17	Magical Machines CH. 10	Mirrors CH. 8	Name the Actions CH. 21	Playing Catch CH. 6	Sing-Along CH. 15	Symphony Of Sound CH. 7	Tell Me A Story CH. 12	Treasure Hunt CH. 19
•	•		•		•	•	•	•	•
		•			•	•	•	•	
•			•		•	•			
		•	•		•	•	•		
								•	•
	•	•			•	•			•
•									•
	•	•			•	•	•	•	•

Games & Exercises

The Payoff	Bending the Rules CH. 14	Can You Top This? CH. 13	Daydreaming CH. 18	Eight Line Scenes CH. 20	Finding the Triggers CH. 22	Group Juggling CH. 11	I Want You To CH. 9
Relaxation			•			•	
Scene Analysis					•		
Spontaneity	•	•		•			•
Understanding Character Needs				•			•
Understanding Conflict							•
Understanding Dramatic Action				•	•		•
Understanding Given Circumstances				•			
Warm-up-Physical	•						
Warm-up-Vocal	•						

Games & Exercises

In Your Own Words CH. 16	Listen Out Loud CH. 17	Magical Machines CH. 10	Mirrors CH. 8	Name the Actions CH. 21	Playing Catch CH. 6	Sing-Along CH. 15	Symphony Of Sound CH. 7	Tell Me A Story CH. 12	Treasure Hunt CH. 19
		•	•		•		•		
•									•
•	•	•			•	•	•	•	•
•									•
				•					•
									•
		•			•	•			
					•	•	•		

Add your notes here:

Sample Curriculum

I considered giving you a detailed breakdown of how I use the games and exercises in my program. However, I abandoned that plan since my schedule may bear little resemblance to yours. Instead, I have prepared a model from which you can extract information that you need to devise an effective curriculum for your situation.

Tips for creating your own program

I have identified the sessions as units. You can spread one unit over two classes, an entire week, or even several weeks, depending on the level of your actors' experience, the size of your class and the time you have.

Let's say, for example, you teach a fifty-minute class and have sixteen students. You might use the first fifteen minutes of the class period for **Sound-Ball** (Chapter 6), followed by a brief discussion, then the last forty-five minutes to begin a unit of scene work. You could continue that unit in your next session. On the other hand, if you have thirty students in the class, that will mean splitting into two groups for **Sound-Ball**. Unless you have a very large space, only one group at a time will be able to work. Obviously, you will tailor this plan to fit your specific needs.

Don't feel you have to rush to introduce new games and don't prematurely judge the results. These workouts will eventually generate remarkable changes in your actors. However, the actors need some time to become completely comfortable with the game

and with one another. Gradually, they will become so absorbed in play that they forget to worry about failing. They will lose the self-awareness that initially inhibited their spontaneity. Then, they will begin to enjoy taking risks and you will see their creativity blossom. For example, in games from **Playing Catch** (Chapter 6), such as **Sound-Ball**, the actors may be stiff and cautious in the beginning. Gradually, their physical actions will become more fluid and they will contribute increasingly creative and complex sounds.

Since I consider the group review after each game an essential part of each workout, I have not mentioned "Group Discussion" in this model. I hope you won't rush through the units and skip these sessions, even if you are discouraged the first time your actors offer comments. This is another area that calls for patience and persistence. No doubt, the first couple of times you play a game, you will need to guide the actors to an understanding of how the playing relates to their scene work. You will need to steer the discussion, offering numerous suggestions. In time, however, the actors will teach *you* things about the games you hadn't imagined.

A prototype

Unit 1
Introduce **Sound Ball** (Chapter 6)
Introduce **Let's Build A Machine** (Chapter 10)

Unit 2
Scene Work

Unit 3
Treasure Hunt (Chapter 19)

If you are working with beginners, you might skip the readings the first time you do this exercise. You could have the class analyze a scene as a group, doing all the work aloud in a group discussion. (It would be helpful, of course, to focus on a role that could be cast as a male or

female.) If you skip the improvisation/readings this time, repeat this exercise soon. Next time, incorporate the on-stage phase of the exercise so your actors can put what they have learned into practice.

Unit 4

Scene Work

If your actors did cold readings for **Treasure Hunt** (Chapter 19), use those scenes for this Scene Work unit.

Unit 5

Games from **Playing Catch** (Chapter 6)

Introduce **Mirrors** (Chapter 8)

Unit 6

Scene Work

If you have a large class, you may have interrupted the Scene Work unit for **Playing Catch** (Chapter 6) and **Mirrors** (Chapter 8). Now you might return to the scenes to complete that unit.

Unit 7

Name The Actions (Chapter 21)

If you are working with beginners, choose one scene and make the breakdown a class project.

Unit 8

Scene Work

Unit 9

Introduce **Daydreaming** (Chapter 18)

Sound Ball (Chapter 6)

Unit 10

Scene Work

Unit 11

Introduce **I Want You To** (Chapter 9)

Unit 12
Scene Work

Unit 13
Games from **Magical Machine** (Chapter 10)
Introduce **Line-By-Line Story** (Chapter 12)

Unit 14
Scene Work

Unit 15
Introduce **Finding the Triggers** (Chapter 22)

Unit 16
Scene Work

Unit 17
Games from **Tell Me A Story** (Chapter 12)
Introduce **Listen Out Loud** (Chapter 17)

Unit 18
Scene Work

Unit 19
Treasure Hunt (Chapter 19)

Unit 20
Scene Work

Unit 21
Introduce **Group Juggling** (Chapter 11)
I Want You To (Chapter 9)

Unit 22
Scene Work

Unit 23
Name The Actions (Chapter 21)

Have your actors work on the scene they are using for the
next unit of Scene Work.

Unit 24

Scene Work

Unit 25

Introduce **Symphony Of Sound** (Chapter 7)

Games from **Playing Catch** (Chapter 6)

Unit 26

Scene Work

Unit 27

Introduce **Can You Top This?** (Chapter 13)

Unit 28

Scene Work

Unit 29

Treasure Hunt (Chapter 19)

Unit 30

Scene Work

Unit 31

I Want You To (Chapter 9)

Unit 32

Scene Work

Unit 33

Introduce **Eight Line Scenes** (Chapter 20)

Unit 34

Scene Work

Unit 35

Introduce **Bending The Rules** (Chapter 14)

Unit 36
Scene Work

Unit 37
Finding The Triggers (Chapter 22)

Unit 38
Scene Work

Unit 39
Introduce **In Your Own Words** (Chapter 16)

Unit 40
Scene Work

A final note

By this time, you have at least introduced your players to each of the games and exercises. At this point, you could return to Unit 1 and cover the forty units again. The second time around you will have more time to introduce variations. When you return to **Unit 1**, for example, you might play three games instead of the two listed. Each time you go over these games and exercises, your actors will get something different from the experience.

Index Of Exercises

Additional Sources

Books:

Barker, Clive. *Theatre Games*. New York: Drama Book Specialists, 1977.

Belt, Lynda and Roberta Stockley. *Improvisation Through Theatre Sports*. Seattle, WA: Thespis Productions, 1991.

Brestoff, Richard. *The Great Acting Teachers and Their Methods*. Lyme, NH: Smith and Kraus, Inc., 1995.

Bry, Adelaide. *Visualization: Directing the Movie of Your Mind*. New York: Harper Perennial, 1978.

Edwards, Betty. *Drawing On The Right Side Of The Brain*. Los Angeles: J. P. Tarcher, Inc., 1979.

Gallwey, Timothy. *Inner Skiing*. New York: Bantam Books, Inc., 1981.

(Any of the Gallwey books including *Inner Tennis*, *Inner Golf*, *Inner Game of Music*, etc.)

Gawain, Shakti. *Creative Visualization*. San Rafael, CA: New World Library, 1978.

Hackett, Jean. *The Actor's Chekhov*. Lyme, NH: Smith and Kraus, Inc., 1992.

Hodge, Francis. *Play Directing*. Englewood Cliffs, NJ: Prentice-Hall, Inc., 1971.

Hodgson, John and Ernest Richards. *Improvisation*. London: Methuen and Co. Ltd., 1966.

Johnstone, Keith. *IMPRO. Improvisation in the Theatre*. New York: Theatre Arts Books, 1979.

Masters, Robert and Jean Houston. *Mind Games*. New York: Dell Publishing Co., Inc., 1972.

May, Rollo. *The Courage To Create*. New York: Bantam Books, Inc., 1976.

Spolin, Viola. *Improvisation for the Theatre*. Evanston, IL: Northwestern University Press, 1963.

Von Oech, Roger. *A Whack On The Side Of The Head*. New York: Warner Books, Inc., 1983.

Tapes:

Gawain, Shakti. *Discovering Your Inner Child, Meditations with Shakti Gawain*. San Rafael, CA: New World Library, 1989.

Hendricks, Gay. *The Art Of Breathing And Centering*. Los Angles: Audio Renaissance Tapes, Inc., 1989.

Add your notes here:

Add your notes here:

Index

We Would Appreciate Your Comments!

Thank you for purchasing *The Playing Is The Thing*. We sincerely hope you will find the book enjoyable and useful. Please let us know:

What do you like/dislike most about the book?

What are your favorite chapters?

If you are a teacher, how does this book help you?

If you are an actor, how has this book helped you hone your craft?

How were you introduced to the book?_____
How did you buy your copy of the book?
☐ Mail order ☐ Bookstore ☐ Other (specify)_____
Would you grant permission for us to use your name, title and comments in future advertising?
☐Yes ☐No
(please print)
Name _____

Address_____

City_____State_____Zip_____

Title_____

Signature _____

Please mail or fax your comments to us. **Thank you!**
Wolf Creek Press
859 Hollywood Way, Suite 251
Burbank, CA 91505-2814
FAX: 818-767-2679

ORDER FORM

Please send me_____copies of the third edition of *Let The Part Play You*.

I understand that I may return the book for a full refund if I am not completely satisfied.

Send my copy/copies to:

PLEASE PRINT your full mailing address:

NAME_____

INSTITUTION_____

ADDRESS_____

<div align="center">(street)</div>

<div align="center">(city) (state) (zip code)</div>

	1 book
LET THE PART PLAY YOU **(Third Edition)**	$15.95
Shipping: $2.25 (For more than one book, add 75 cents per book)	+2.25
For one book shipped to an address outside California—TOTAL	**$18.20**
Please add 8.25% sales tax per book if shipped to a California address	+$1.22
TOTAL	**$19.42**

Make your check or money order payable to: **Wolf Creek Press**

Send your check or money order **along with this order form** to:

<div align="center">

Wolf Creek Press
859 Hollywood Way, Suite 251
Burbank, CA 91505-2814

</div>

(Please do not send cash)

Please allow 4-6 weeks for delivery.
Thank you for your order.

ORDER FORM

Please send me_____copies of *The Playing Is The Thing*.
I understand that I may return the book for a full refund if I am not completely satisfied.

Send my copy/copies to:

PLEASE PRINT your full mailing address:

NAME_____

INSTITUTION_____

ADDRESS_____
 (street)

 (city) (state) (zip code)

	1 book
The Playing Is The Thing	$16.95
Shipping: $2.25 (For more than one book, add 75 cents per book)	+2.25
For one book shipped to an address outside California—TOTAL	**$19.20**
Please add 8.25% sales tax per book if shipped to a California address	+$1.40
TOTAL	**$20.60**

Make your check or money order payable to: **Wolf Creek Press**

Send your check or money order **along with this order form** to:

Wolf Creek Press
859 Hollywood Way, Ste. 251
Burbank, CA 91505-2814

(Please do not send cash)

Please allow 4-6 weeks for delivery.
Thank you for your order.

Add your notes here:

About The Author

Anita Jesse has been acting, teaching acting, and directing since 1960. In 1970, she received a Master of Fine Arts degree in Dramatic Production from the University of Texas at Austin. Since 1978, she has run her own studio in Los Angeles and coached hundreds of actors who work in film, television, and stage.

While Anita teaches at her studio in Los Angeles most of the year, she also conducts professional and academic workshops across the country. She frequently appears as a guest lecturer at universities and university-sponsored seminars for actors and theatre educators.

While coaching actors in Los Angeles, Anita has pursued an acting career. Her work in film, television, and stage has earned her numerous awards including Best Actress, 1982, from the Christian Film Distributors' Association.

Ms. Jesse is one of the twenty-two acting teachers profiled in *Qualified Acting Coaches: Los Angeles*, by Larry Silverberg (Smith and Kraus, 1996). Ms. Jesse's own earlier work, *Let The Part Play You,* serves as the required text in academic and professional training programs across the country.